DUNFERMLINE & DISTRICT

From Old Photographs

KATE PARK

Best Wishes
Kate Park

AMBERLEY

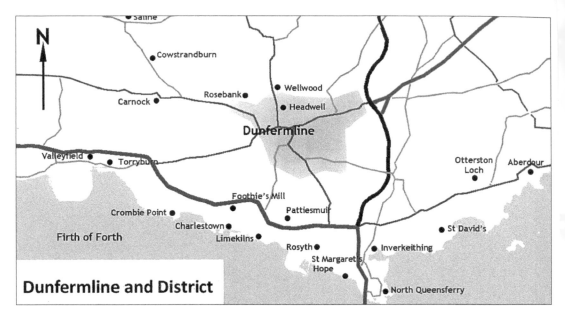

Dunfermline & District map.

*To dear Russells past – Mum, Russ, Violet, Vicky, Rex – and dear
Russells present*

First published 2014

Amberley Publishing
The Hill, Stroud
Gloucestershire, GL5 4EP

www.amberley-books.com

British Library Cataloguing in Publication Data.
A catalogue record for this book is available from the British Library.

ISBN 978 1 4456 4018 1 (print)
ISBN 978 1 4456 4027 3 (ebook)

Typesetting and Origination by Amberley Publishing.
Printed in the UK.

Contents

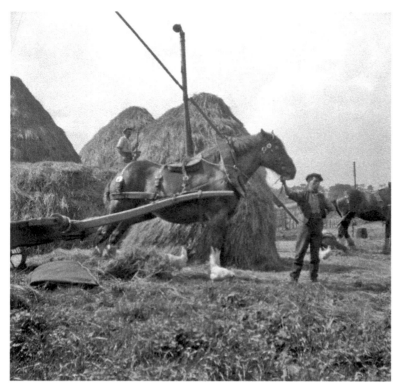

My great-grandfather saw photography not just as an end in itself. He painted many of the wonderful scenes he photographed. It is hoped that through this book, some of these J. R. paintings may come to light.

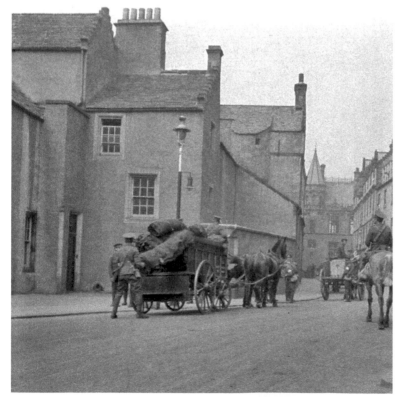

First World War soldiers in Dunfermline. The soldiers are loading kitbags on to a waggon and the size of them suggests it may be their tents. The other waggon has a box with an arrow on it, which signified property of the war department.

Introduction

My great-grandfather, James Russell, was a house painter by trade, but, from an early age, showed a talent both for photography and art. His drawings and paintings were signed 'J. R.' long before a certain Texas oilman made the initials infamous. But as James' hair became greyer and his brow more wrinkled, he became known as 'Auld Jimmy', although it seems unlikely that anyone had the nerve to call him that to his face! Considering that most of the photographs in this book date from the 1920s when my great-grandfather was into his threescore and ten years, I doubt if the ever-active James thought of himself as 'auld' anyway.

The cupboards in his Abbot Street shop were chock-a-block with *National Geographic* magazines, art periodicals and boxes of photographic plates that produced most of the photographs in Chapter One.

But after he died, all James' 'junk', including many paintings that adorned his walls, was flung into a damp cellar by his daughter Jean. Although just a teenager at the time, my mother had the foresight to rescue some photographs and a bundle of small 2x2 negatives from his shop drawer, that, until 1988, remained wrapped in Auld Jimmy's makeshift envelopes.

This whole project began back in 1989, my husband printing each of the 880 negatives using the old fashioned dark room technique. More recently, the negatives were digitally scanned – a much less time consuming job! But it was no easy task identifying all the images, as the collection features not only Dunfermline and its surrounding villages, but also places in Scotland from James' trips further afield, like Edinburgh, the East Neuk of Fife and as far north as Killin. It is therefore worth noting that only a quarter of the photographs feature in this book – such is the quality and quantity of this unique collection.

Sadly, some of those acknowledged for their help in my research are gone, but their contribution has been invaluable ... none less so, than that of my mother. Not only did she rescue J. R.'s negatives and photographs, she also remembered so much about the great man himself.

Thanks mum (7 November 1917–5 October 1995).

Acknowledgements

The following people were of great help back in 1989 when the whole project began. Firstly, and most importantly, my husband, who started it all by deciding to print every negative; the staff of the Local History Department of Dunfermline Carnegie Library (a special belated thank you to Chris Neale); the Revd Stuart Macpherson, who supplied me with details about James' father, William Russell; my dear departed old friend, William Marshall, who kept me enthralled with tales of days gone by, especially those related to farming; and more recently Sarah Dallman of the National War Museum Library, Edinburgh Castle; the staff of the Black Watch Museum, Perth, and Sue Mowat, who has been a great help in reading through the text and keeping me right on local history.

REFERENCES

Roberts, Enos H. G., *The 9th Kings (Liverpool Regiment) In The Great War 1914–1918* (Leonaur Ltd 2007, first published 1922).

Taylor, Simon, Markus Gilbert, *The Place-Names of Fife. Volume 1* (Shaun Tyas, 2006).

The National Library of Scotland map website.

Black, Adam and Charles, *Black's Picturesque Tourist of Scotland: Twelfth Edition* (1856) (Auld Jimmy's personal copy). This guidebook has been the subject of the recent television series, *Grand Tours of Scotland*, written and presented by Paul Murton.

These are examples of the 2x2 negatives and a paper cover that Auld Jimmy used to wrap each bundle. He's written 'Soldiers 1914' on this one.

James Russell: Photographer

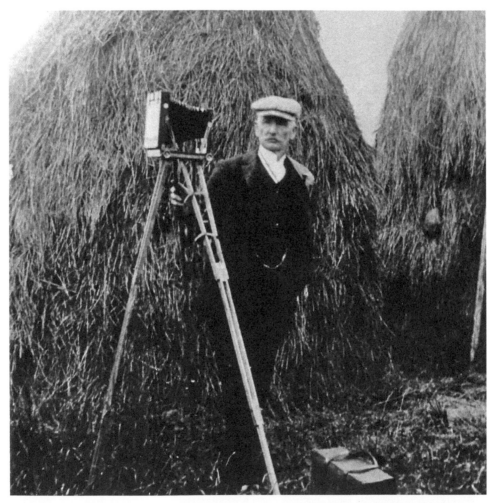

My great-grandfather James Russell, in his early sixties. William Henry Talbot (1800–77) was the English claimant to the invention of photography with his negative/positive process, and it was this that evolved into the photography we know today. In 1853, a Mr Louis opened the first photographic establishment in Dunfermline, charging 2s 6d for each 'likeness' or portrait. By the 1880s, there were at least fifteen studios in the town. Growing up in this age of the camera, its little wonder James became such an enthusiast.

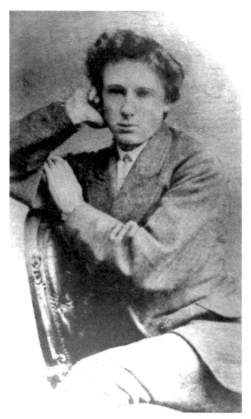

My great-grandfather, James Russell, was born in 1849, in Baldridgeburn, Dunfermline, into a family of weavers. Aged around eighteen in this photograph, he was then living in Chapel Street. The family moved to No. 18 Maygate when James' father William took up the position of beadle in Dunfermline Abbey. James' parents later moved to No. 55 New Row and, in 1907, after forty years in the post, William retired with a pension of 10s a week. He died in 1918, aged ninety-one.

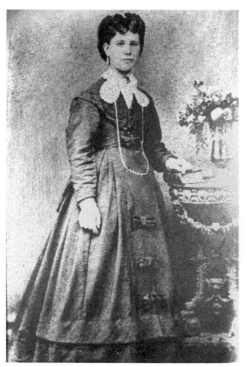

My great-grandmother, aged eighteen. James and Anne were married at Whitemyre, Rumblingwell, on Hogmanay 1872, regarded as an auspicious day to wed. The whole occasion was a Russell affair – Anne was a Russell (no relative), the best man and bridesmaid were Russells and even the minister was a Revd Russell! My great-gran often boasted that James had fought six 'fellaes' to win her heart and hand.

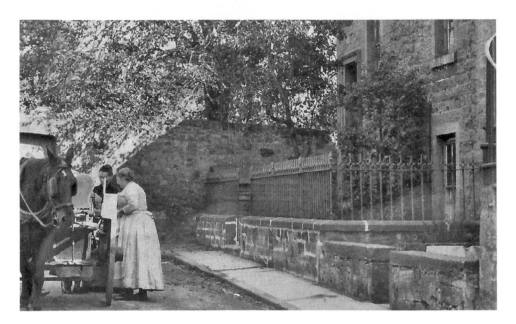

Edgar Street in the 1880s. The door in the wall, behind the horse, led to the grounds of Priory House, later converted into the Nurses' Home of the Dunfermline and West Fife Hospital. James and Anne lived in Beveridgewell, then moved to Edinburgh around 1878, but, by 1884, they had returned to Dunfermline and were living at No. 23 Edgar Street.

James' daughter, Jean, in the back garden of Edgar Street, around 1884. This street dates from 1827 and was demolished when John Holt built the casualty department of the Dunfermline and West Fife Hospital 1955–58. It has since been replaced by New City House and the flats of the revived Edgar Street. Reid Street, seen running down to the left, was built in 1820 on the site of the servant's path to the abbey, known as 'Gillie's Wynd'.

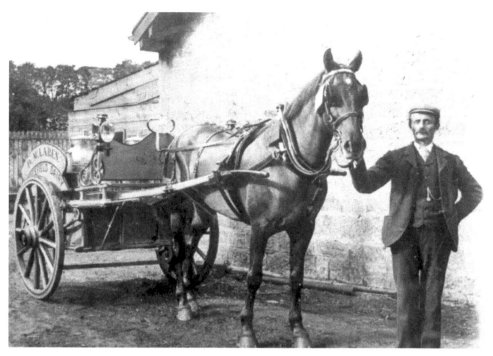

Brucefield Farm and its dairy were situated to the south-west of Brucefield Avenue area. This photograph dates from the 1890s. D. McLaren is written on the side of the cart.

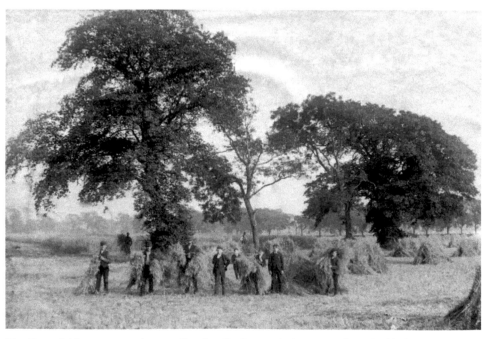

The Brucefield area around 1890. Dunfermline's population more than doubled between 1861 and 1911, and consequently many streets of houses were built, including Brucefield Avenue. James and his family moved from Edgar Street to Nos 75–77 Brucefield Avenue around 1900.

The Brucefield Avenue area looking eastwards, with Woodmill Street on the left. When James again moved, he let out No. 77 Brucefield Avenue to my grandfather, and it was there my mother was born on 7 November 1917. She often recalled the beautiful frieze of harbour scenes that James had painted above the picture rail in the lounge. The man in the bowler hat may be James' only son, Will.

Looking west towards Bothwell Street and its railway viaduct, built between 1874 and 1877. These men are clearing the land, ready for building. When James first moved here there were still trees remaining, prompting my gran to call it 'The Plantin'. Note that there is no sign of the tin kirk (*see page 13*). This dates the photograph from the early 1890s. The present day St Leonard's church opened in 1904, thanks to a legacy from the draper William McLaren.

The Auld Tin Kirk, or Brucefield parish church, sometime between 1894 and 1902. It was opened in 1894 to serve the growing community in the area. Tin churches were mainly designed and made in kit form. The most common type was timber framed, externally clad with galvanised corrugated iron and lined with tongue and groove boarding. This made for an incredibly durable structure and many in England still survive. Internally, there was often a high level of decoration. Note the arches of the railway viaduct centre right.

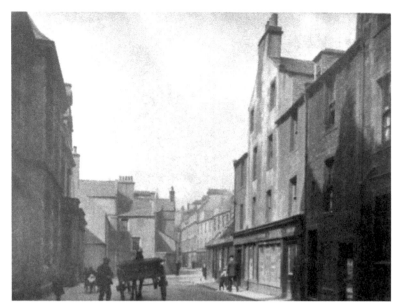

Looking along Abbot Street towards Maygate. The houses on the right were demolished and replaced by the parish council offices in 1912. James leased his first shop, at Nos 2–4 Abbot Street, around 1908, and then moved to No. 15 Maygate, where he set up a business of house decorating, picture framing and sign writing. He proudly painted his name over the shop window using an old fashioned style, to read JAMES RVSSELL. He was then advised, by a passing ignoramus, that he'd made a spelling mistake!

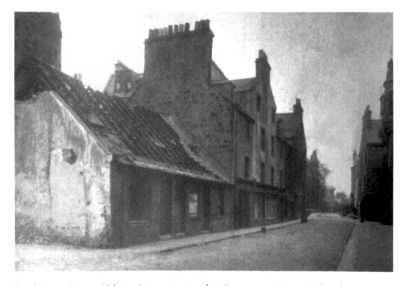

Looking along Abbot Street towards Canmore Street. The latter was originally known as 'in below the wa's' (east part), but in the sixteenth century was more commonly known as the Foul Vennel. In 1811, it was renamed Canmore Street.

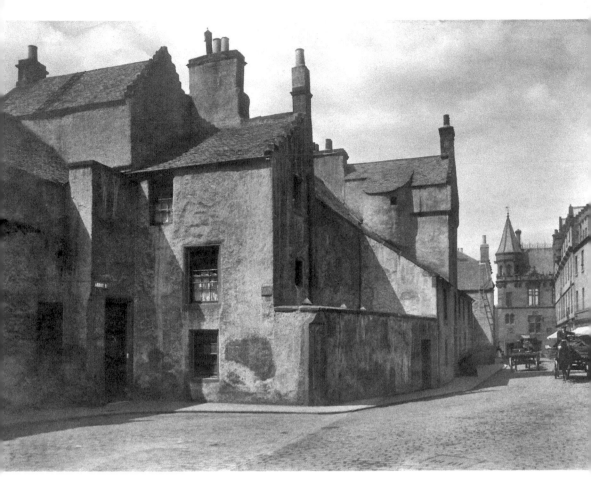

This photograph of Abbot House and Maygate dates from before 1909, as the old building at the west end of Maygate, shown with the ladder against its wall, was demolished that year. In 1914, while workmen were digging foundations on the site of the former Masonic Hall, on the south side of Maygate, there was a 'gruesome discovery' of skeletons; a reminder of the time when this area was part of the churchyard. One of the skeletons was face down, prompting my gran to think the person had been buried alive; consequently, she decided to be cremated when she died. In 1752, the east end of Maygate was one of the first places in Dunfermline to be graced with a street lamp.

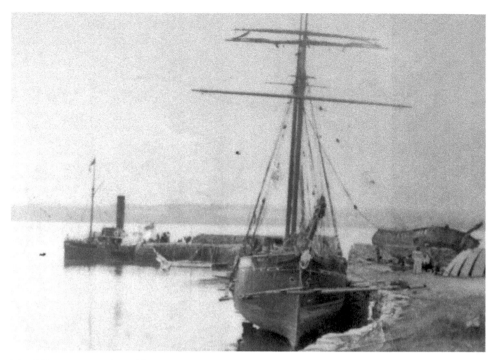

Limekilns, c. 1900. A paddle steamer can be seen picking up passengers in the background. This village on the shores of the Forth was first known as Gellald, or Gellet, and came to be known as Limekihil, Lymekil, and the present Limekilns, after the clamp kilns or lime pots that used to lie along the shore. Coaches and steamers stopped here en route to Edinburgh, Alloa and Stirling until the start of the twentieth century.

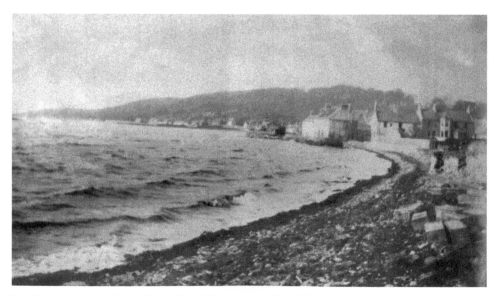

Looking west towards Red Row, Limekilns, c. 1900. Limekilns was immortalised in fiction when R. L. Stevenson mentioned it in *Kidnapped*. Set in 1751, Balfour and Breck stop at an inn before crossing the Forth. This hostelry is believed to have been Breck House in Red Row.

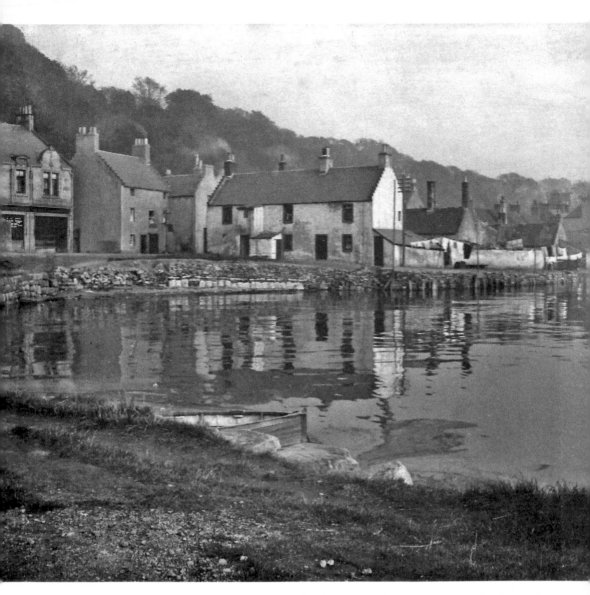

This photograph of Limekilns, looking towards Pierhead cottage and Main Street, was dated 1910 by Auld Jimmy. In 1931, a concrete esplanade became the main route through the village and caused much controversy. Not only had much of the popular sandy shore disappeared, but many protested that the new addition was not in keeping with the old houses.

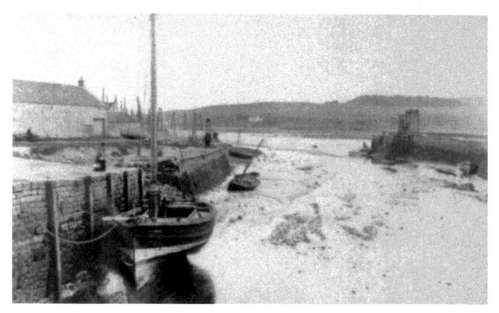

The Keithing Burn, East Harbour, Inverkeithing. During the First World War, when James was photographing an Inverkeithing building scheduled for demolition, he failed to notice the Army camp situated behind it. Confronted by two Army officers, he was promptly arrested under suspicion of being a spy. His bike, his camera and even his tie were confiscated (in case he hanged himself!) Confined to a cell, he was released when the police in Dunfermline were contacted and replied vehemently, 'Let Mr Russell out at once – he's one of the most respected men in the town!'

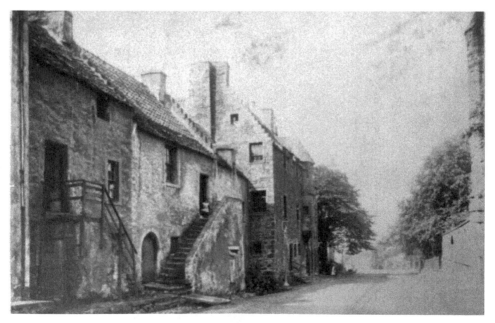

Church Street, Inverkeithing. The building with the stone fore stair was known as Claverhouse. It was demolished in 1913 to allow access to the new primary school. The nearest house was later the site of the Queen's Hotel stables.

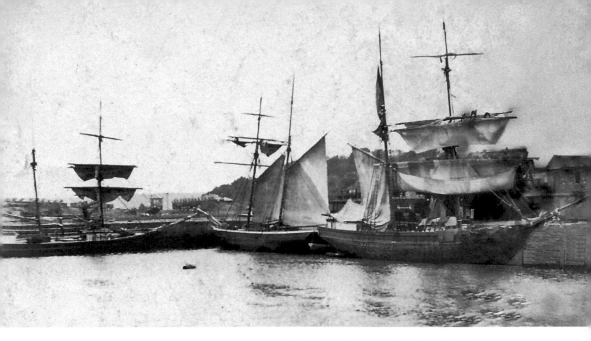

Looking west, St David's Harbour, *c.* 1900. In its heyday, trading vessels and yachts belonging to the local nobility were a familiar sight in the harbour.

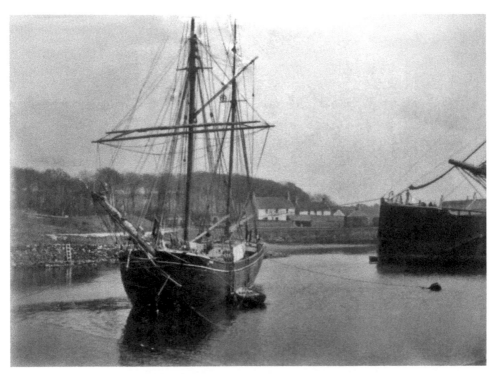

Looking east, St David's Harbour, *c.* 1900. In 1752, Sir Robert Henderson began constructing a harbour to export coal from his Fordell pits. The harbour had two small piers, one of which was built on a rock known as St David's Castle. This gave its name to the village that grew up around the harbour and, by 1836, the population had grown to 142.

Looking towards my great grandfather's shop in Abbot Street in the 1920s, with Abbot House on the right. James moved to No. 12/14 Abbot Street, and it is there that he lived until his death in 1933. Nos 10–14 Abbot Street was built in 1895 for the joiner Alexander Mitchell. It is interesting to note that our Russells seemed to colonise this part of Dunfermline, living at Nos 13, 15, 18, 30 (where I was born in the front bedroom) and No. 32 Maygate.

Auld Jimmy's wife and his son-in-law, Ebenezer (better known as Abe), outside the Abbot Street shop in the 1920s. Ebenezer Tod was working as a farm servant when he was gored to death in 1940 on Colton farm, William Street, by a bull he had looked after since its birth. He was fifty-nine.

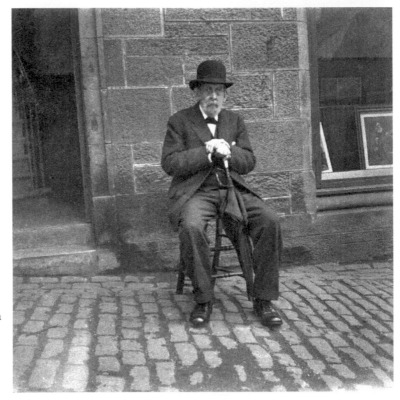

Auld Jimmy's brother-in-law, John Russell, outside the entrance to No. 14 Abbot Street. He was a wealthy coal merchant who lived at No. 56 Nethertown, and was married three times. He died in 1923.

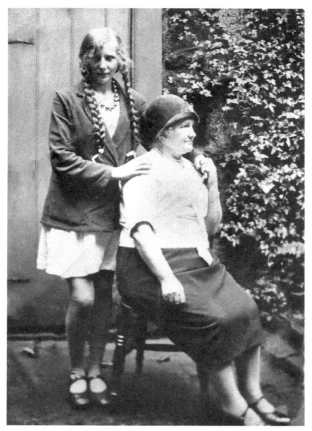

Auld Jimmy would offer to take your 'portrait.' This one is of my mum and my gran taken in the backyard of No. 30 Maygate around 1932. Photography as a hobby became easier following the introduction of the Brownie camera in February 1900, by the Eastman Kodak Co. of Rochester, New York. With no need for the cumbersome plates of earlier years, the snapshot became very popular.

My mother (sitting down) with Stella, James' youngest grand-daughter, in the backyard of No. 30 Maygate. Stella grew up to become a GI bride and moved to California.

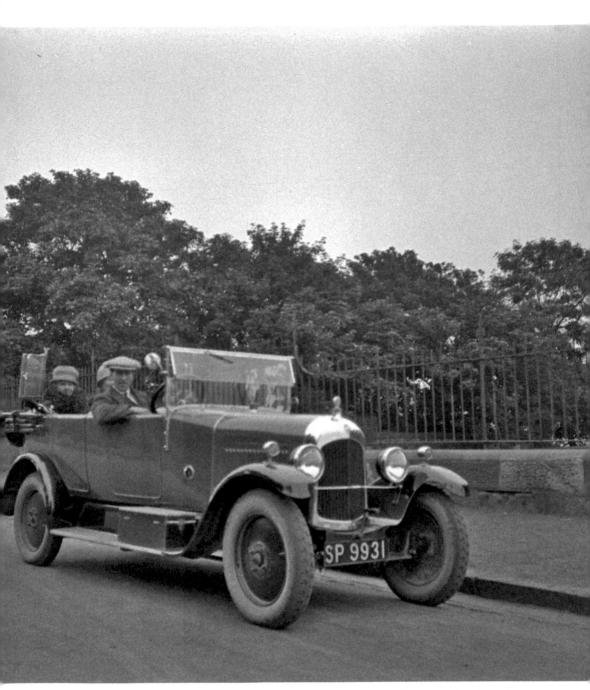

Auld Jimmy's son-in-law (my grandfather), wife, daughter and grandchildren are all set for a day out. The number plate dates this car from between 1924 and 1925. James and my grandfather were great friends, and he either chauffeured Auld Jimmy around or accompanied him on cycling days out. He pops up in a few of the photographs in this book, usually having a 'fag break', while my great grandfather set about composing and taking his pictures.

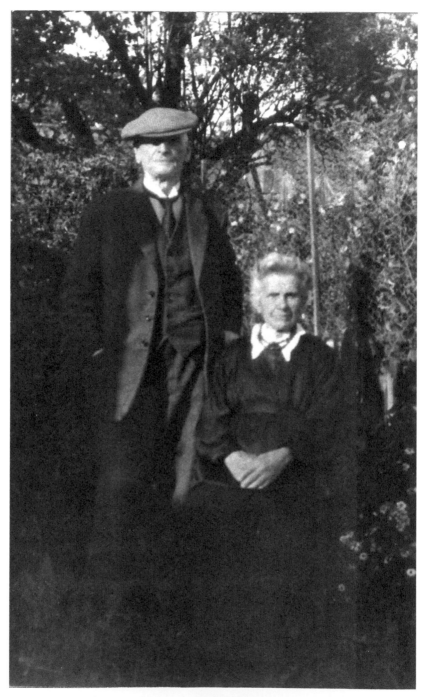

My great grandfather and his wife in their late seventies. Auld Jimmy died on 28 June 1933, aged eighty-three, following a stroke, My great grandmother died on 7 May 1936, aged eighty-four. She often told my mum, 'We were like twa doos in a doocot.' Up till now, two lines from Gray's 'Elegy in a Country Church Yard' may have seemed an appropriate epitaph for James Russell. 'Full many a flower is born to blush unseen, And waste its sweetness on the desert air.' Not now, I think...

Chapter 2

Dunfermline Town

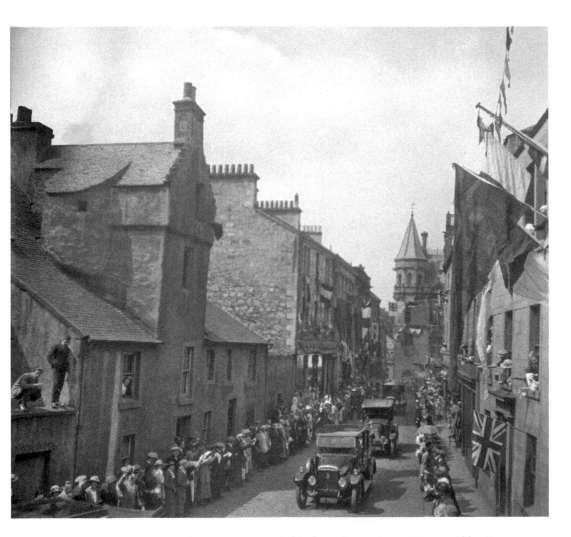

This has been taken on 13 July 1923, most probably from the window of No. 14 Abbot Street, when King George V, Queen Mary and the Duke and Duchess of York (later George VI and Queen Elizabeth, the Queen Mother) came to Dunfermline. A triumphal arch was erected in the Kirkgate to celebrate the first visit of a reigning monarch for 300 years. It was estimated that 30,000 townspeople and visitors lined the route.

Abbot House can be seen on the left, alongside the men and their tar making machine. Dating from the second half of the fifteenth century, it was originally a house with two rooms on the ground floor and two above, one of the ground-floor rooms being used as a smithy. In 1573, it was bought by James Murray of Perdieus, who extended the house to the east and north. A further eastern extension was built in the eighteenth century. Throughout the centuries, it has continued to be home to various people and establishments. On 14 April 1995, Provost Margaret Millar opened Abbot House, or 'The Pink Hoose', as the Dunfermline Heritage Centre.

The building with the Abbot Street sign was demolished to make way for the car park behind Abbot House. The new museum will be built behind the building on the left. This land was purchased by the Commercial Bank of Scotland in 1838, and its original building was set back from the street. The frontage to Abbot Street was added in 1883. In 1905, it was bought by the Carnegie Dunfermline Trust and became their headquarters. From 1952, it was used as council offices.

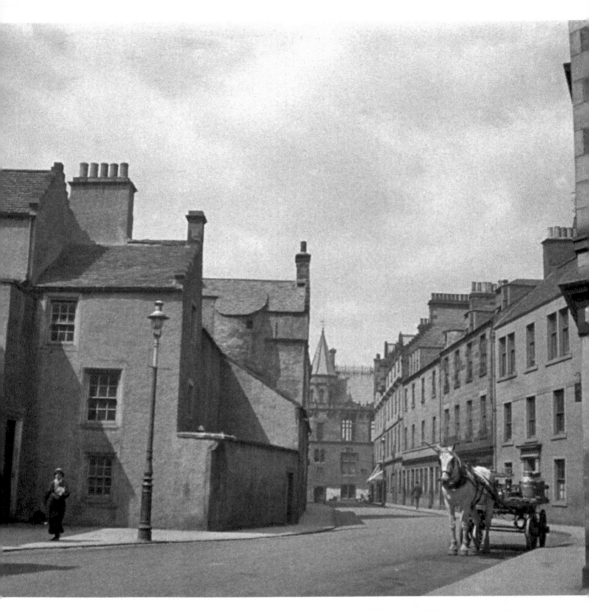

The north side of Maygate was developed early in the history of the town. The houses on the south side were built in the churchyard, beginning with the first phase of Abbot House. The 'May' element might be an old word meaning water. The lade that powered the Heugh Mills passed along the street in a stone-built channel. A public well was situated at its west end.

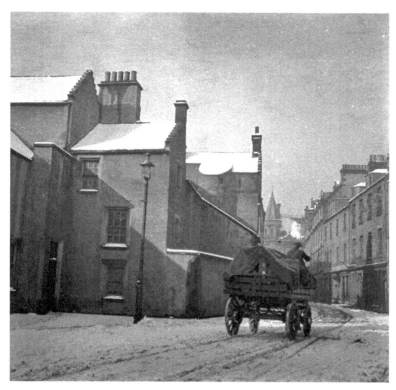

Two wintry scenes in Maygate; the first showing, most probably, the station cart delivering parcels dropped off by train. When James and his family moved here, this part of the town was regarded as one of the most desirable places to stay.

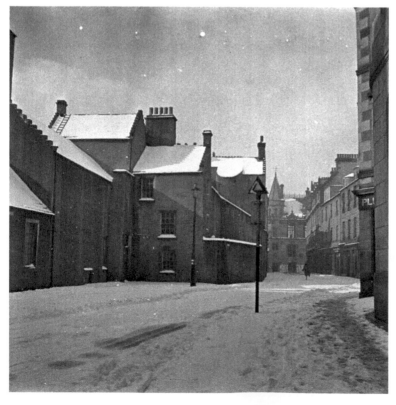

This photograph shows an open triangle traffic sign, which indicated a hazard or warning. This dates the picture from between 1930 and 1933, the year Auld Jimmy died. Before 1934, regulations for traffic signs created by the Road Traffic Act 1930 meant that road signage specifications were only advisory.

Chapel Street. Originally an access lane to the Mill Dam, it was first known as North Chapel Street when two chapels were built there in the eighteenth and nineteenth centuries. The Chapel Kirk, later St Andrew's church, was demolished in 1987. The Relief Kirk is now Gillespie church. The house on the right was the manse for the original Relief Kirk, and dates from around 1794. When James lived in this street, his brother William died of scarlatina in 1860, aged six. His other siblings, Lizzie, Jean and Joseph were born here.

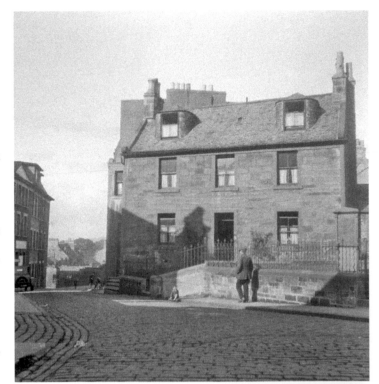

This little shop at the end of Chapel Street, was no doubt frequented by the residents of the Model Lodging House, situated on the opposite corner. It was opened in 1900 for the destitute and homeless. This road now leads to the bus station.

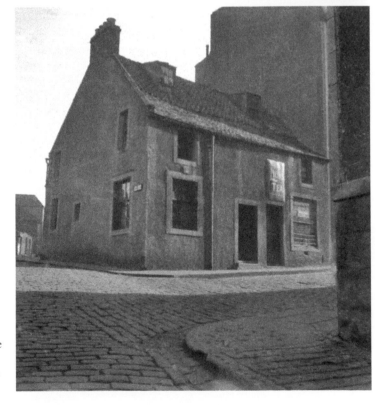

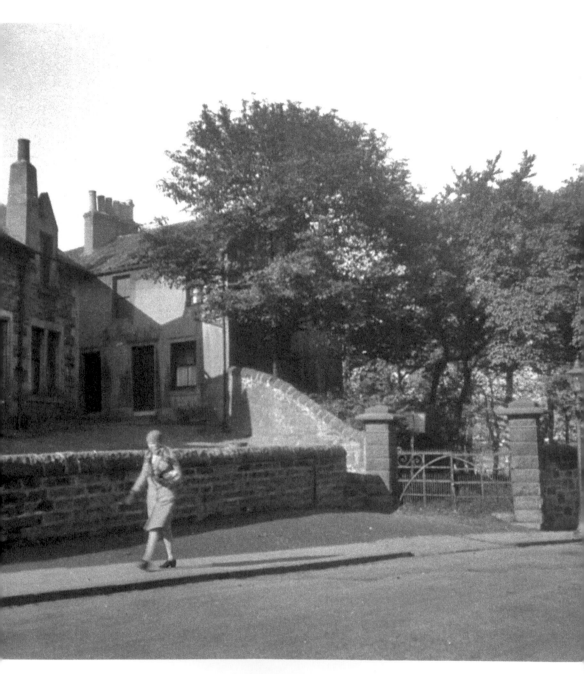

Damside Street. Also known earlier as Back of Dam, its name originated from the old Mill Dam, which, in 1867, became the site of the Canmore Linen Works. Later becoming a continuation of Bruce Street, it was widened in 1933/34, and much of this area was turned into a car park around 1967. The gates led to Sir Joseph Noel Paton's House, in Wooer's Alley, demolished many years ago. Today, this area has been radically changed, in preparation for the Tesco store scheduled to open in 2014.

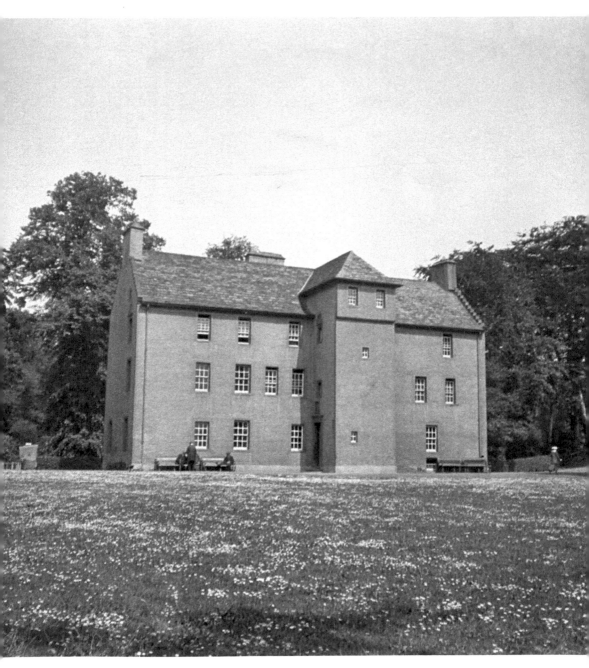

Pittencrieff Park. Sir Alexander Clerk of Penicuik built Pittencrieff House in 1610, and a third storey was added in 1740. Brig.-Gen. John Forbes who lived in Pittencrieff House, captured the French port, Duquesne, in 1758, which he renamed Fort Pitt after the British Prime Minister. Later known as Pittsburgh, it was here that Andrew Carnegie made his fortune and thereby the means to buy the estate and Forbes' former residence for £45,000 in 1902, gifting them to the Dunfermline people the following year. Pittencrieff means 'estate of the tree or trees'.

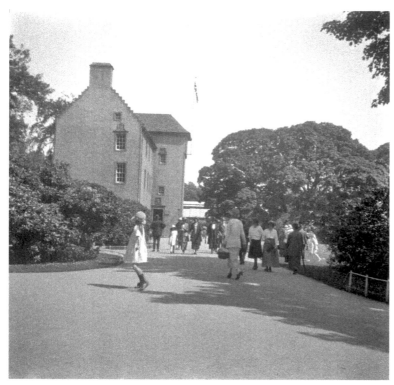

A bright summer's day in the 1920s. Between 1904 and 1911, work was carried out convert Pittencrieff House to a club and museum. Sir Robert Lorimer supervised the conversion of the upper floor into a single gallery in 1911. On a more macabre note, Pittencrieff Park was the scene of a murder in 1912, when a woman was shot dead by a local barman. In 2010, the house had been repaired, reharled and painted its distinctive ochre shade, in time for its 400th anniversary.

In contrast to the above photograph, this was taken on a winter's day. Note the conservatories in the background. These were opened in 1911 by Dr John Ross and, along with the gardens, were renowned for their horticultural displays. These glasshouses were replaced in 1973.

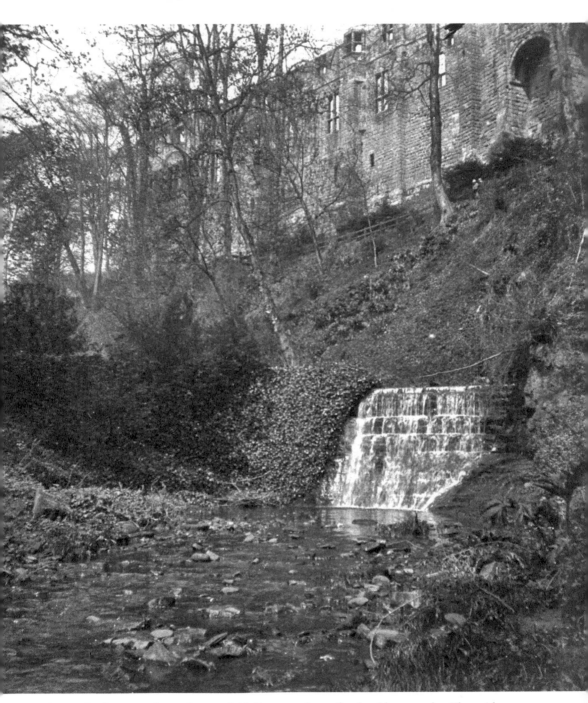

The royal palace grew from what was initially a guest house for the abbey complex. The residence was later enlarged and improved, by James V and VI. Charles I, the 'Dunfermline laddie who lost his heid', was the last king to be born here in 1600. The Glen Falls helped to give Dunfermline its name. Dun means a fortified hill, (Tower Hill) Ferm or Ferme means bent or crooked, (the meandering of the Tower Burn) and Lin, Lyn or Line, a cascade or pool.

After King James VI departed for England as a consequence of the Union of Crowns in 1603, the last king associated with the palace was Charles II, who signed the 'Dunfermline Declaration' at the palace in 1650. With the palace deserted by royalty, it was also deprived of care and attention. In 1708, the north wall collapsed and the roof fell in. Ensuing years of further neglect took a heavy toll and the royal residence fell into ruin, its stones being used in the construction of local buildings.

The Japanese-style teahouse, with its open-air veranda, was built in 1904 and extended three years later. This photograph possibly dates from around 1919. The woman may be Gwen, Auld Jimmy's grand-daughter, who married Ian Stevenson of the auctioneers and house furnishers in Bruce Street. In later years, it merged with McKissock's. Beyond the teahouse are the stables and estate office. These burned down in 1936.

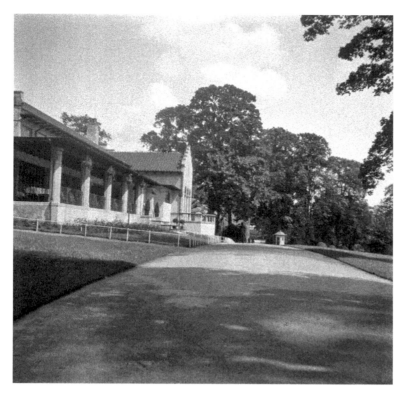

The Cape-Baronial cafeteria designed by John Fraser replaced the old teahouse, seen in the previous photograph, in 1927. A music pavilion was added later in 1934. On the right is the distinctive telephone box, built in 1928. In February 1990, it became a Category B listed building.

Looking down towards the Double Bridge over the Tower Burn. This was the main route into Dunfermline, from the west, until the mid-eighteenth century. The wall, on the right hand side, with the window, was part of the estate office and stables. The Italian garden and toilets are now accessed from here. Behind the couple is the Chalmers Bridge, built around 1770 by the then owner of Pittencrieff estate, Mr George Chalmers. Their clothes suggest this was taken in the early 1930s.

The Pan fountain was moved from here to the present lily pond in the Italian garden – the site of the former stables and estate office. After its recovery from being stolen in 1994, the decision was taken to keep it safe, away from the public.

An idyllic view of the Tower Burn, beside the summer house to the left and Malcolm's Tower to the right. Quoting from Black's *Picturesque Tourist of Scotland* (1856):

> The principal antiquities of Dunfermline are the Tower of Malcolm Canmore and the Palace, both situated in the grounds of Pittencrieff, the property of James Hunt Esq., who kindly permits visitors to inspect them.

In 1903, Andrew Carnegie gifted us the opportunity to do so much more in the grounds of Pittencrieff!

The St Catherine's Wynd building behind the trees, on the right, was occupied by S. Hodgson, a wholesale and retail, glass, china and earthenware merchant.

Looking up from the Tower Burn towards the back of Bridge Street. Note the name 'JOHN RUSSELL DRAPER' on the top of the building in the centre. This was probably a relation of Auld Jimmy.

Public Park. From its time of opening in August 1863, cows were grazed in the Public Park. In 1929, the town council's proposal to graze sheep instead of cows was declined, as it posed a hazard to those driving through the park. Cows were grazed here during the Second World War. The bandstand, gifted by Mrs Carnegie, and officially opened on 23 June 1888, was not one of my great-grandfather's favourite landmarks. He thought it a blot on the landscape! The original town grazing was on the town green and muir and, on 30 April 1785, records show there were sixty-four cows grazing at 24s each. The revenue was £76 16s, and this income was of great help to the town's funds.

This distinctive house, Morton Lodge – Transy Place – was built c. 1875 and is now known as Barum House. It was home to James Shearer, the architect whose granddaughter, Moira Shearer, was the famous ballerina and star of *The Red Shoes*. She was born in Dunfermline in 1926 and married Ludovic Kennedy in 1950. She died in January 2006. In 1970, St Margaret's and Commercial primary schools were built in the field to the right of the house. Despite a public outcry, the Eastern Relief Road was opened through the park in 1986, to ease congestion in the town.

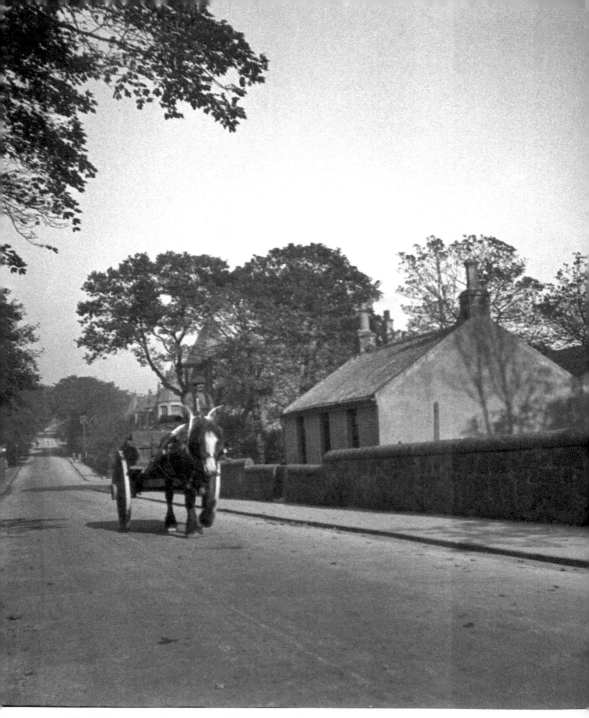

Reek-Ma-Lane. This 'but and ben', situated at No. 98 Pilmuir Street, was a landmark in Dunfermline. But, despite being one of the oldest houses in the town, *The Dunfermline Press*, on the 4 January 1961, carried the headline, 'Reek-Ma-Lane must go says Town Council'. The house had been let out for much of the 1950s, but after inspection by Corporation officials, it was deemed unfit for habitation and made subject to a demolition order.

With an endless list of repairs ranging from rising damp, inadequate lighting and ventilation to a cracked chimney, it didn't seem economical to invest in repairs, despite a housing shortage at the time. In such a sorry state, 'Reek-Ma-Lane' was valued at £30. After £1,200 of renovations, the house was still only reckoned to be worth £1,000. The only feasible option left was demolition, and so Dunfermline lost an irreplaceable part of its history. Semi-detached houses now stand here.

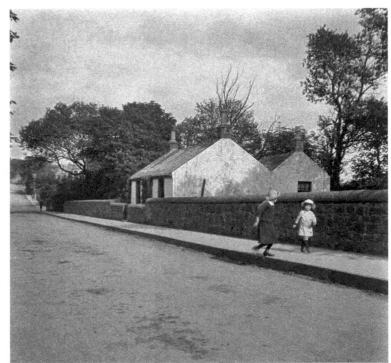

Headwell. This quaint cottage situated off Headwell Road survived up to just a few years ago, having now been replaced by the houses of Royal Scot Way. Behind it is Canmore golf course, opened in 1902. The well was originally dedicated to St Margaret and decorated annually with flowers on her Saint's Day. It later became known as Headwell. Headwell was also the location of something more sinister – 'the toun's gallows'. John Cummin, the last Dunfermline hangman, died in 1770.

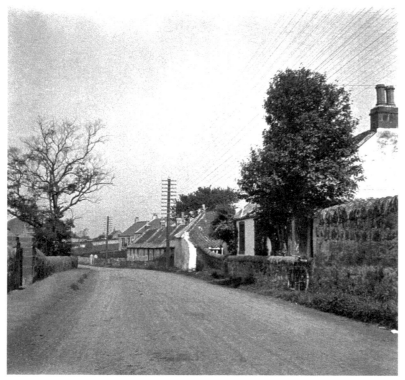

Carnock Road. The cottages on the roadside have gone as a result of road widening. In 1737, according to Burgh Records, public races were established, and ordained to be run annually along Carnock Road at the June Fair. Auld Jimmy's bike is propped against the wall on the right-hand side – it appears in a lot of his photographs. Look out for it.

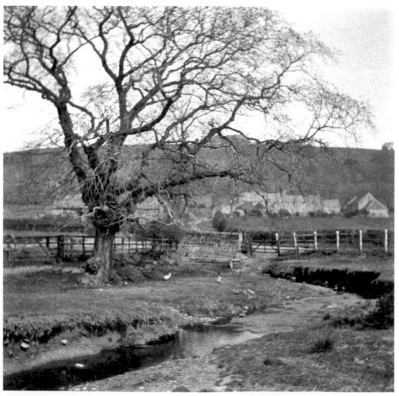

Craigluscar Farm and its distinctive hill behind. There is an Iron-Age fort on the top, which is protected by a triple rampart. It was excavated in 1944/45, and again in 1988. Behind the tree are old stone cottages that have long gone. Craigluscar originally formed part of the Easter Luscar lands and, from the early sixteenth century, the area was closely associated with the Durie family.

Rosebank. This is possibly the ruins of the Fernieknowe Colliery engine house. Fernieknowe pit was located west of the North British Railway Lochhead branch at the Elgin Crossing, north of Baldridge House. It was operational from the 1830s to around the 1890s, and was most probably owned by the Elgin Colliery. This colliery was located across the Parkneuk, Baldridge and Rosebank areas in the eighteenth and early nineteenth centuries.

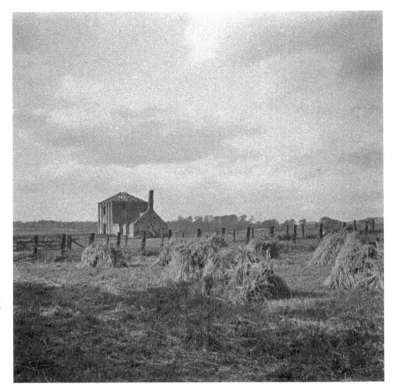

Looking towards the ruin of the Fernieknowe engine house on the left, with evidence of the rail track and its buildings clearly visible on the right. Coal from the Elgin pits was transported via the Elgin Railway, down to Charlestown harbour. Small industries round Charlestown, such as the brickworks and foundry, saltworks, sawmills and kilns needed coal, but the bulk of it was exported to other parts of Scotland. The Elgin coal was regarded as very suitable for steam engines, and the coke produced in the kilns was sent across Europe and to Boston, USA.

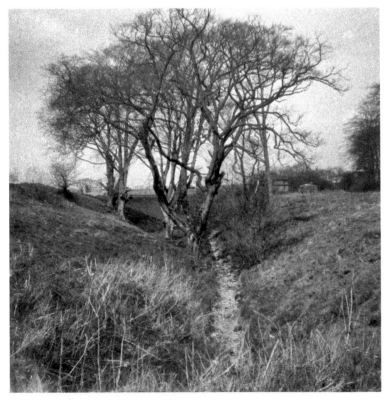

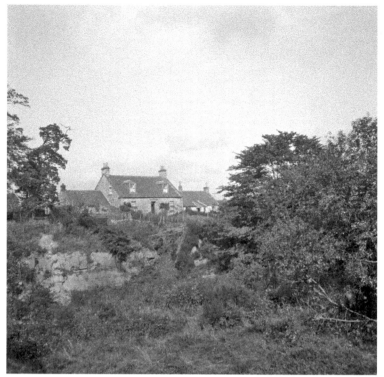

Nether Rosebank Cottage is located east of Rosebank Mains and can be accessed by a path at the top of Blackburn Avenue, Parkneuk. Note the quarry in front of the house. The district around Rosebank Mains and Nether Rosebank, to the north-west of Dunfermline, had been mined for centuries, but its coal was used more for steam and cooking. It was not considered a good enough quality for heating the home.

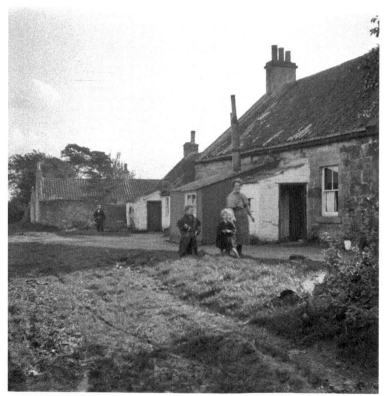

The back of Nether Rosebank Cottage. Auld Jimmy has many photographs of this cottage and environs. His son-in-law, Ebenezer Tod, came from the nearby Swallowdrum Farm, so perhaps this is the reason he frequented the area so often. The main house is now just a shell. The cottage behind the man is the only habitable building now.

Berrylaw. Sometimes referred to locally as 'granny's gairden', the name Berrylaw means 'burgh hill'. There may have been a village here around 1700 and, in the 1820s, the mining villlage of Berrylaw was often mentioned. According to old maps, the colliery was active in 1853, but, by 1896, production had ceased. This chimney may be the remains of a colliery building. The historiam, D. Beveridge, also mentions an infamous lot called the Medmenham Club who held orgies here. One of its members, Lord Sandwich, had a lady friend who came from Berrylaw.

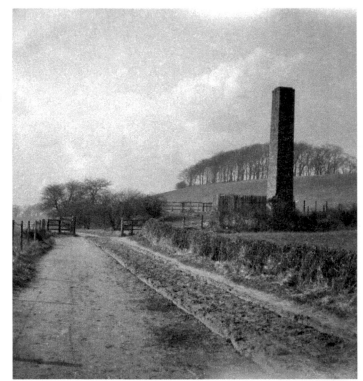

Looking from the Berrylaw area, back towards Dunfermline, with the abbey steeple clearly visible. Part of William Street can be seen on the left, and the roofs of James Place, now demolished, down to the right. The sandstone quarries at Berrylaw and North Urquhart provided what was regarded locally as the best stone. Some of the houses in Grieve Street were built from Berrylaw stone, the quarry being leased by the builder, George Dick. Note the air shaft on the right.

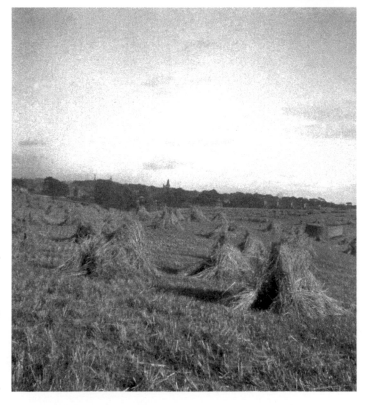

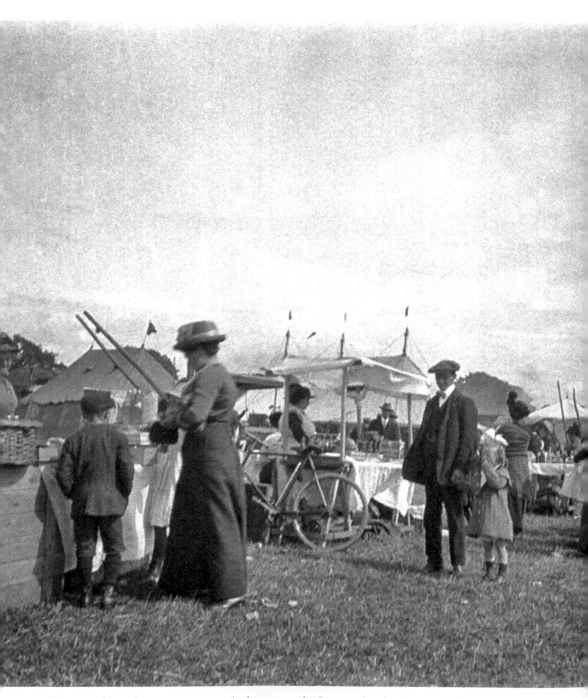

This part of Urquhart Farm came to be known as the Race Park, after it was decided, in 1883, to hold the Dunfermline and West Fife subscription race meetings here. This photograph and the following two may date from around 1920. Note Auld Jimmy's bike.

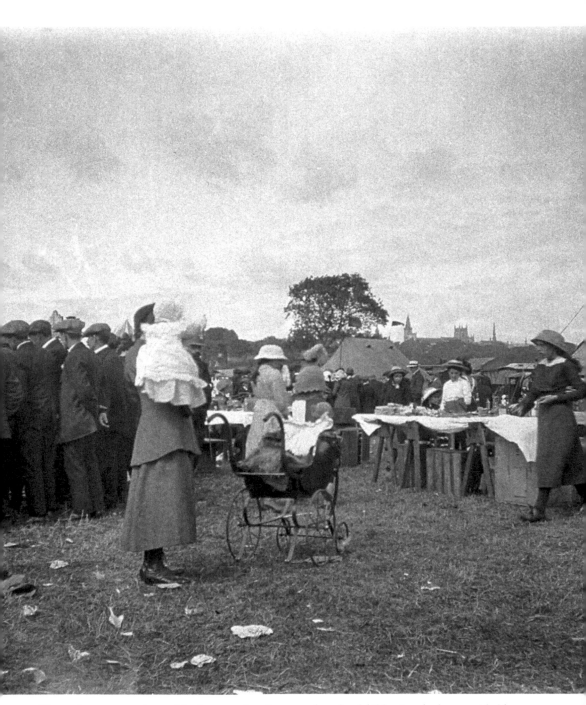

The park was not only used for horse racing. In 1903, the schoolchildren's gala day, provided by Mr and Mrs Andrew Carnegie, was inaugurated on 21 August when a treat was held at the Race Park. The Highland Games were held in this field for years, and the Dunfermline Rugby Club played here from about 1904 to 1906 before relocating to Lady's Mill Park (McKane Park).

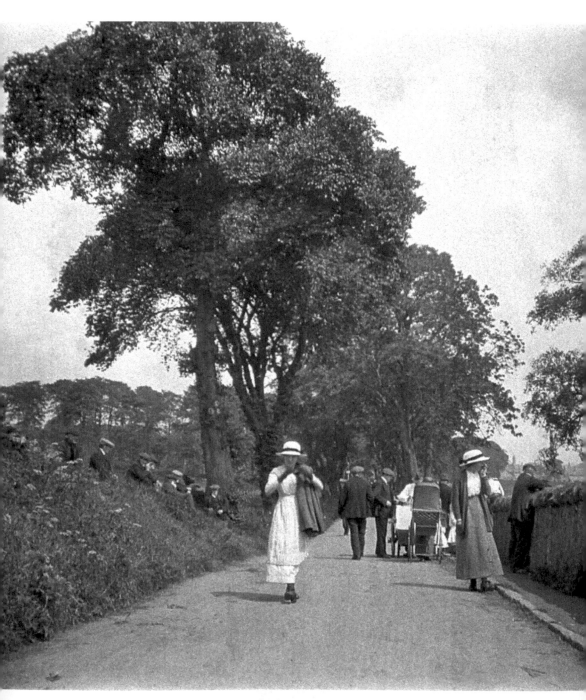

Looking eastwards along Logie Road. The men sat on the verge are probably anticipating an event in the Race Park opposite. A family friend recalled one particular race when a spectator took matters into his own hands. With his selection trailing in third place, the crafty character took out his 'gutty', or catapult, and fired a ball bearing at the horse. The jockey could barely hold on as the animal galloped first past the post like a thing possessed! Note the ice cream seller behind the pram.

A later photograph of Logie Road looking towards Milton Green, the site of a spinning mill up until the early part of the nineteenth century. This road leads back westwards to Logie House, home of the Hunt family. The field on the far right is now built up with the housing schemes branching off from Abington Road.

Looking east along Lover's Loan before it was widened in 1927. The road was occasionally known as Sailor's Walk because of its popularity with courting couples. My great grandfather referred to this area as Hunt's Dykes – a reminder of the time from 1800, when the Hunt family owned Pittencrieff Estate, until it was purchased by Andrew Carnegie in 1902. Off to the left is the Coal Road, so called because of the horse-drawn trucks that journeyed down it, en route to the port of Limekilns in the seventeenth and eighteenth centuries.

Looking from Limekilns Road towards the recreation ground of McKane Park. This was named in honour of the benefactor Mr John McKane (1862–1911), who had bought Lady's Mill Park from Col. John Hunt for £2,500 and presented it to the Dunfermline Cricket club in 1906. In 1972, a new pavilion was opened, and the grounds are still used today for cricket and rugby. The housing development of Liggar's Place was built in the 1980s and now overlooks the park.

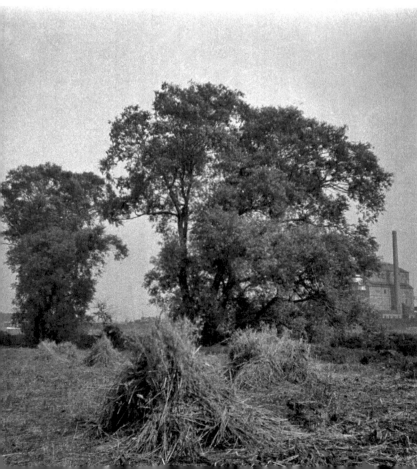

Taken close to Limekilns Road, this photograph shows the back of Dickson Street on the left, and the gasworks, Grange Road, opened in 1883. Today the Elgin Industrial Estate dominates this area.

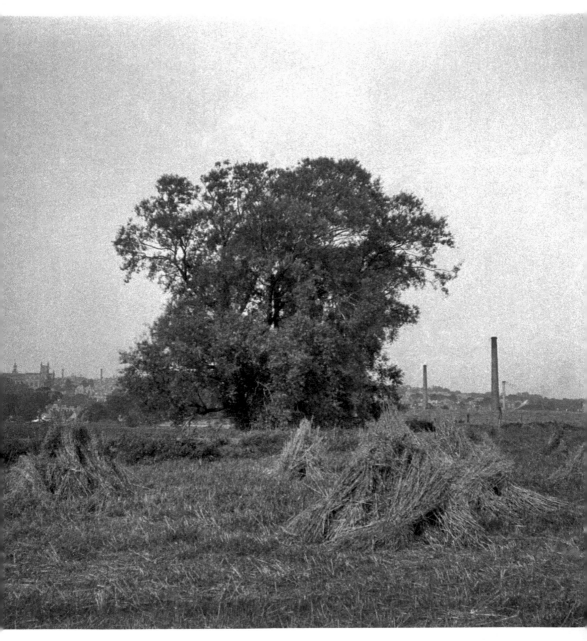

Again taken close to Limekilns Road, the nearest chimney on the right is that of Ralph Stewart's Rubber Works on the west side of Elgin Street, which closed in 1957. The next belongs to the Bothwell Linen Works, on the east side of Elgin Street, and the furthest away chimney is that of the Dunfermline and West Fife Hospital.

Chapter 3

Just a Bike Ride Away

Limekilns. The two cottages beside Pattiesmuir, a village near Limekilns, are now one home called Brucehaven Cottage (formerly known as Burnside Cottages), whereas the rather dilapidated building behind (seen more clearly in the photograph below) has long since disappeared. Pattiesmuir was once a weaving community, its 'college' being used by weavers as a meeting place. The forebears of Andrew Carnegie lived in the village from around 1760 to 1830. It also boasted the 'palace' of the King of the Gypsies.

According to old maps, this cottage was known as Earnyside. A clump of trees is all that remains. To the left is Douglas Bank. It was chosen as the site for a graveyard in the middle of the 1914–18 war, and opened afterwards as a memorial cemetery. There seems to be no obvious sign of it here, so these photographs probably date from before 1918.

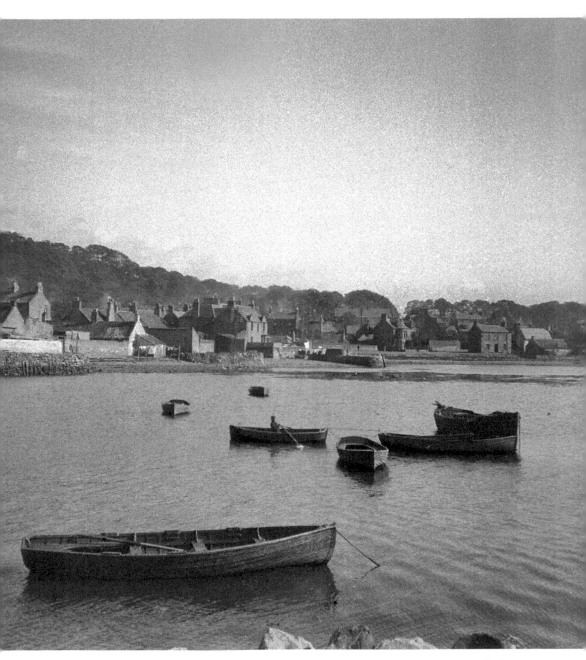

Where houses now stand, there used to be a small stone pier called 'Baillie's Battery'. It had a cannon, salvaged from the Peninsular Wars, on the seaward side, which fired salutes for special occasions. The Battery was demolished in 1931 and the rubble used in the construction of the promenade. As early as 1089, the monks of Dunfermline used the lands of Gellet and, in 1362, King David II constituted Limekilns a port for use of the abbots, monks, merchants and burgesses of Dunfermline.

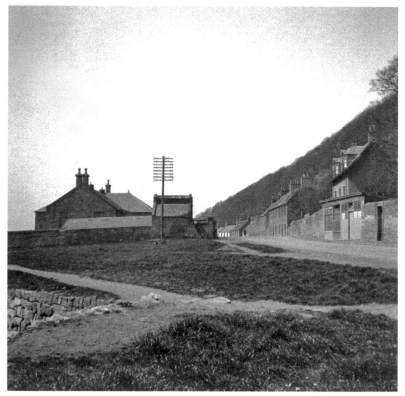

In 1863, the old harbour wall was pulled down to make way for the building of the Pierhead School, which, in the 1920s, was the centre for concerts and meetings. People preferred to meet there, rather than leg it up the brae to the Queens's Hall. There was a barber's shop opposite the school and, in the 1920s, there were around twenty-six shops in the village.

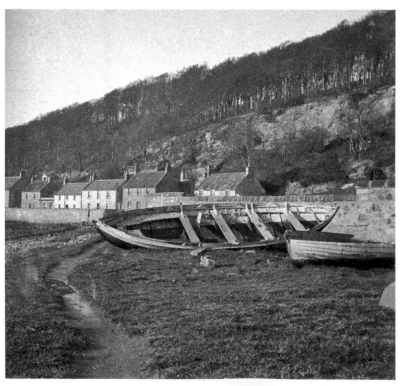

Looking along the esplanade towards Halkett's Hall – a part of the village that has remained relatively unchanged. Most of the houses were built around 1828. Limekilns folk were keen observers of the Sabbath. On one occasion, the local policeman called at a house to enlist help to take five Swedish workmen into custody. Employed on the building of the Forth Bridge, these men had committed the heinous crime of singing on a Sunday!

Taken from Limekilns pier. The white house beside the shore is called Pierhead House. The 1910 photograph in Chapter 1 (page 17), shows the protruding part of the house as flat roofed, with an adjoining lean-to. In this later photograph, it is more like a turret and the lean-to has gone. When Limekilns was popular as a holiday resort, rowing boats were available for hire at the pier.

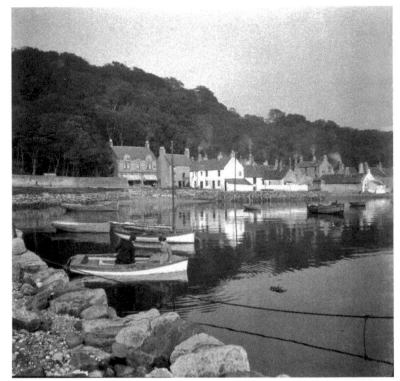

The big event of the summer in Limekilns was the Regatta. Roundabouts, swings and blaring music arrived several days before the event and, on the great day, there were stalls stretching all the way down the main street to the pier. As can be seen from this photograph, the pier was not in the best of order. In 1934, it was rebuilt by the local unemployed.

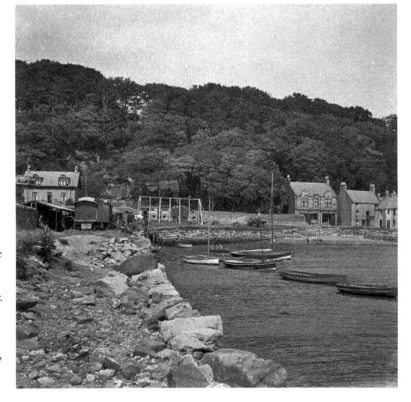

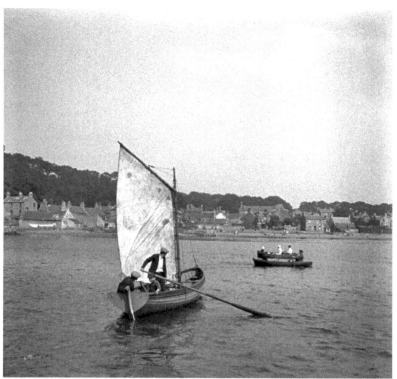

Looking towards Red Row. Limekilns Regatta featured rowing as well as sailing events in the old days, and the village could boast many a powerful oarsman.

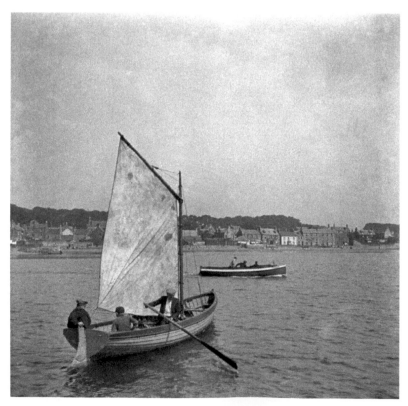

The races ran from Limekilns pier round the Charlestown buoy, then down the river to the Capernaum buoy and back again to the Limekilns pier.

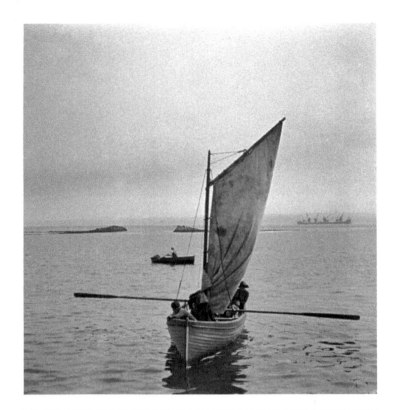

An entrance was cut through a reef of rock bounding the south side of the harbour to make a feature known as the Ghauts, derived from an old Scots word meaning 'trench'. This can clearly be seen in the centre of the photograph. Exports included salt (seventeenth century), lime, coal and ironstone, with ironstone and lime being shipped across the Forth to the Carron Ironworks in the 1800s. The ship in the background is probably a dredger.

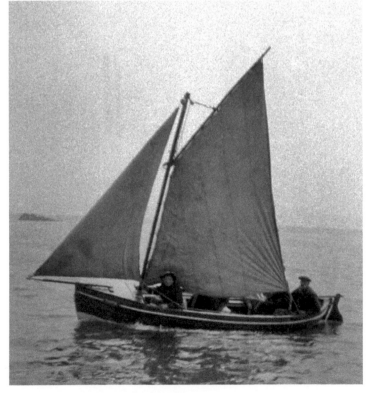

Built at the beginning of the sixteenth century from cliffstone, Limekilns harbour was much more protected from the wind than Capernaum pier. Mary Queen of Scots allegedly embarked from here after escaping from Loch Leven Castle. In the 1800s, Limekilns was a bustling port with its many ships and sailors, some of whom had served under Lord Nelson and Adm. Napier.

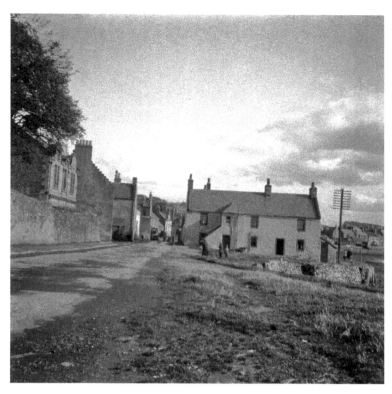

Looking east down Main Street with Pierhead House on the right. The building on the left once belonged to the Dunfermline Co-operative Society. Today, it is a popular bistro/hotel. Another shop in Main Street used to hire out bicycles.

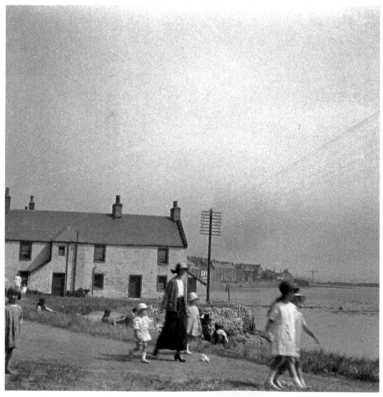

In the distance is the familiar crane at the Rosyth Dockyard. The decision to build the dockyard was taken in 1903. The tidal basins and two graving docks were built by Easton Gibb & Son Ltd, 1909–14. The workshops began in 1915.

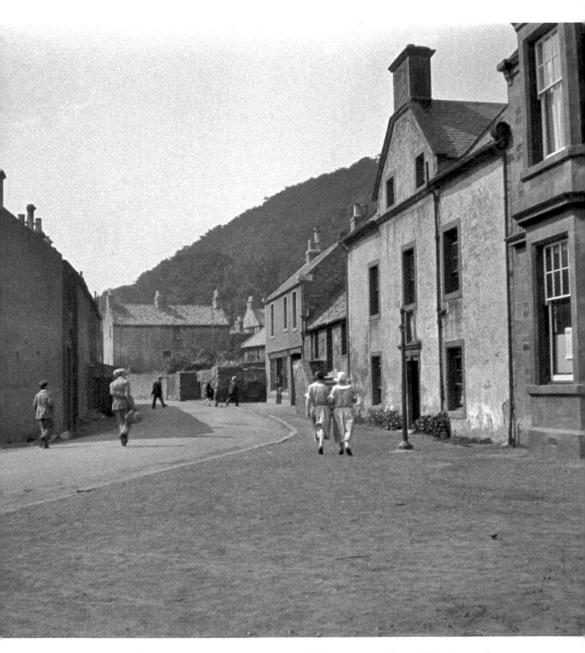

Main Street has a few interesting old houses. Two of the most notable are Warrington Court, possibly dating from 1640, and one next to the Bruce Arms Hotel, called Brewstead or Brucestead, which has the remains of a malt kiln behind it. Further up is the Sundial Café, a quaint cottage with a distinctive sundial on its wall. The King's Cellar in Academy Square was used for the storage of wine and other valuable imports. After the Reformation, it was used by the Dunfermline merchants.

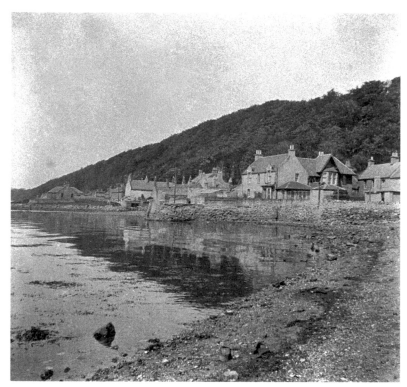

At the extreme left, is the Bucket Pat or Pierhead school, which was built in 1864. After the present school opened in 1912, the old one was still used for village functions, until it was demolished around 1931.

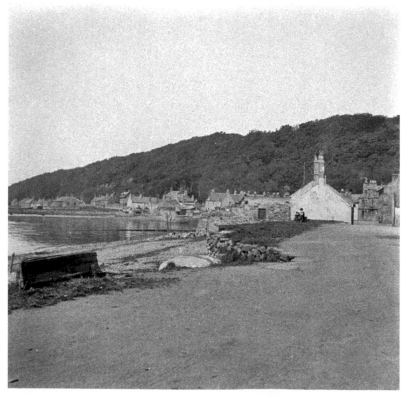

This photograph has been taken from Red Row, the area of Limekilns associated with curing fish and salt manufacture. Behind the man reading the newspaper are two cottages; one of my great aunts stayed in. When it was high tide, the kitchen was flooded out!

Looking eastwards along the area between Capernaum Pier and the old Rosyth churchyard, known as Brucehaven Bay. Note the Fifie Drifters in the foreground. The rope works at Capernaum were installed in the pantiled building in the photograph. Flax, used in the local weaving industry, was also important in the manufacture of rope – the rope being needed by many of the boats repaired in this area. Soap was also made here. The Muir Homes Charles Way Development was built further along this shore in the late 1970s.

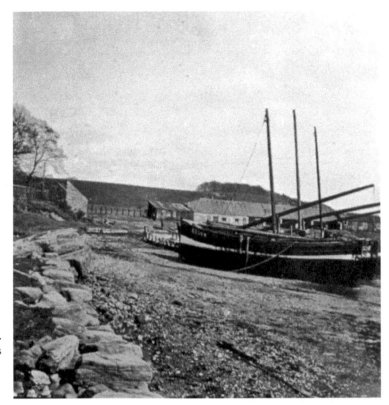

Brucehaven Bay was a popular place for family outings. Centre right of the photograph is the early eighteenth-century house that, today, houses the Forth Cruising Club (started just prior to the First World War). Just east of Capernaum pier was a sawpit used in shipbuilding. In 1823, 200 carpenters were employed building ships, but when Limekilns trade declined, only small boats were constructed. By the start of the twentieth century, the yard was only used for repairs.

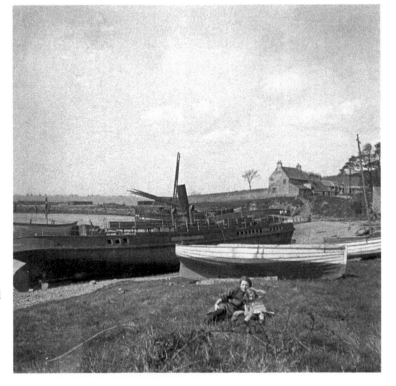

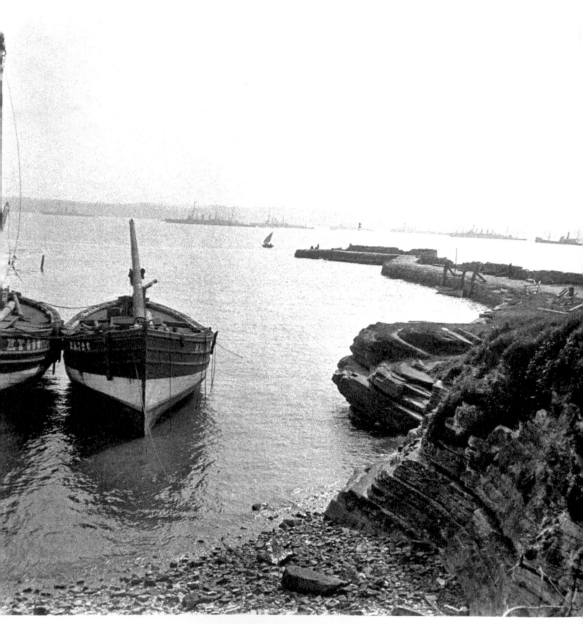

Brucehaven harbour was built by Forbes of Pittencrieff in 1728, and Capernaum pier was built between 1774 and 1776 for the Chalmers coal trade. Because this pier was not particularly well sheltered, a low wall was built in 1870 to help protect the small boats. A fleet of ships can be clearly seen in the background of this photograph. In 1917, during the First World War, the smaller ships of the Grand Fleet were anchored off Limekilns, and a large number of sailors came ashore to worship in the village. The KY-registered (Kirkcaldy) Fifie Drifters are on the left.

Charlestown, The Saltpans. Poor grade coal was used to evaporate the sea water in large metal pans. The coal used was called Panwood. Charles, the Fifth Earl of Elgin, founded Charlestown between 1756 and 1758, having recognised the potential of developing this area and its great mineral wealth of coal, limestone and sandstone.

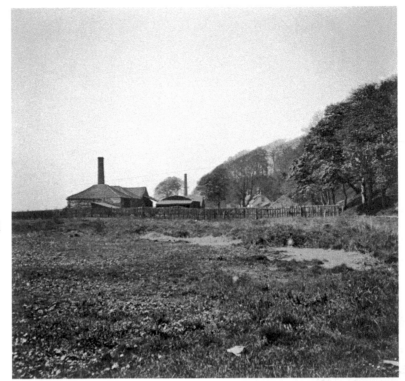

At one time, the Forth basin was the main area in Scotland for salt production. The tall chimney and a few saltworks buildings survived until the late 1960s, when they were demolished to make way for housing. The name 'Saltpans' was adopted as the street name for the new scheme.

Easter Cottage. Now a listed building, this attractive house was built for the limekilns' manager in the early nineteenth century. Construction of a village to house the Earl's workforce began in the 1760s and continued until 1820. With its main streets arranged in the form of a C and E, Charlestown was one of the first planned villages in the country. Because of its resistance to seawater, Charlestown's quarried limestone was used in the construction of Leith and Dundee docks. The lime was of such high quality that, in the late 1700s, it was believed that the kilns were the greatest perhaps in the universe!

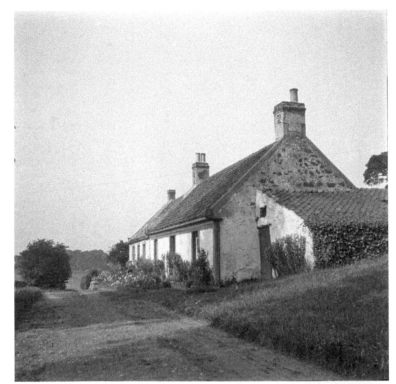

Courthill, Charlestown. These cottages are located near Merryhill on the farm track that leads down to the Sutlery. They have survived and look little different from Auld Jimmy's day.

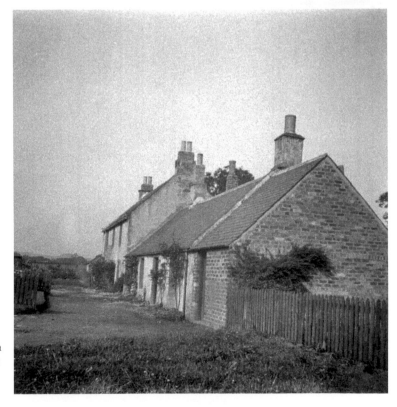

Fiddler's Hall, Charlestown. Also known as Floral Hall, this house is situated on Charlestown Road as it passes from Merryhill to the Cairns.

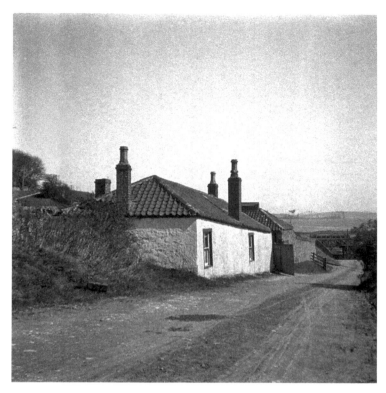

Shell Road, Charlestown. Once a main route down to the harbour, it is now barely a path. Note the wooden bridge. The lower station was opened in 1894 by the North British Railway, but was closed and dismantled in 1926 when passenger services ended. Charlestown's importance as a port declined after 1890, when the Forth Bridge was opened and the whole of eastern Scotland became accessible by rail.

Shell Road. This is the dairy cart, probably delivering milk to the houses down at the harbour. At one time, there was a dairy in Rocks Road. In 1767/68, building was started on Charlestown harbour, its walls and quays being hewn from a 70-foot sandstone cliff. It was reconstructed in 1830 and, in 1860, was acquired by the North British Railway Co. According to an advertisement in the *Dunfermline Journal*, April 1855, 'Charlestown Harbour is very easy of access and the shipping arrangements afford every facility for the expeditious loading of vessels.'

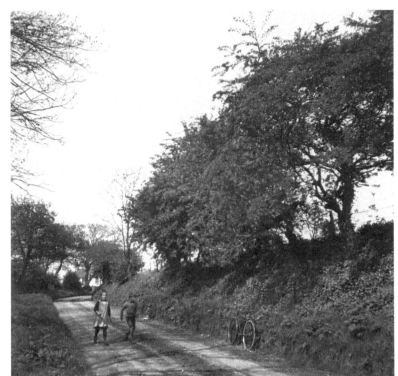

Looking up to the top of Shell Road, a house is clearly visible. The photograph below is one of that house. Again note Auld Jimmy's bike.

This house was at the top of Shell Road, across from Fiddler's Hall and along from The Cairns. It has now been replaced with a modern house. The stone wall and the trees are still there. The old kilns in Charlestown are now labelled dangerous, but my mother recalled that a child recovering from whooping cough was encouraged to drink the lime water. This was aided by a well set into the kiln wall, with an accompanying cup on a chain. How advisable this was is debatable!

Foothie's Mill. Also known as Foddis, Foody, Feddy's, Fiddes & Fethie's Mill, it lay between Waulkmill and Merryhill Farm on the A985, beside the Lyne Burn. The surrounding land was once owned by Culross monastery (founded in 1217) and, by the fifteenth century, the mill was established by its monks.

The White Friars of Culross used it as a grain mill, and the adjacent Waulkmill to clean and thicken woollen cloth. The mill was later taken over by a Robert Carnis and then, in 1592, it was leased by Gilbert Fod and later by John Fethy. In time, these two surnames became the basis of the name that endured – Foothie's Mill. Grain was ground there until around 1815, when a Frenchman converted it into a snuff mill.

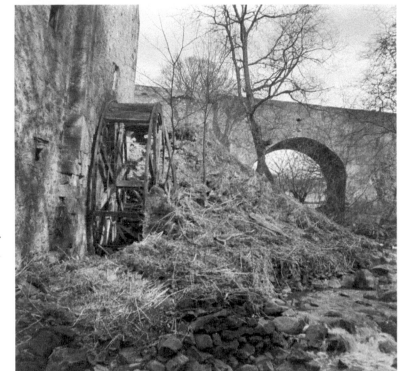

After standing idle for many years, the wheel beside the Lyne Burn was removed in the 1940s. According to old records, in 1603, the Lyne Burn, at its lowest reaches, was referred to as the Foody Mill Burn.

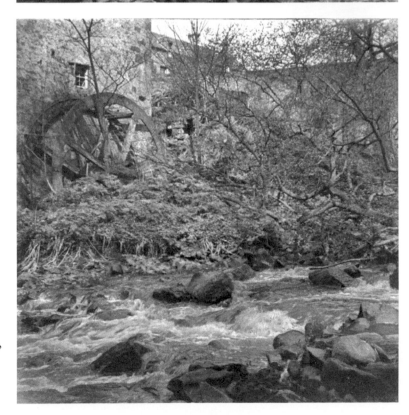

The mill was demolished in 1969 when the A985, the main route from Rosyth to Kincardine, was improved by widening the above bridge over the Lyne Burn.

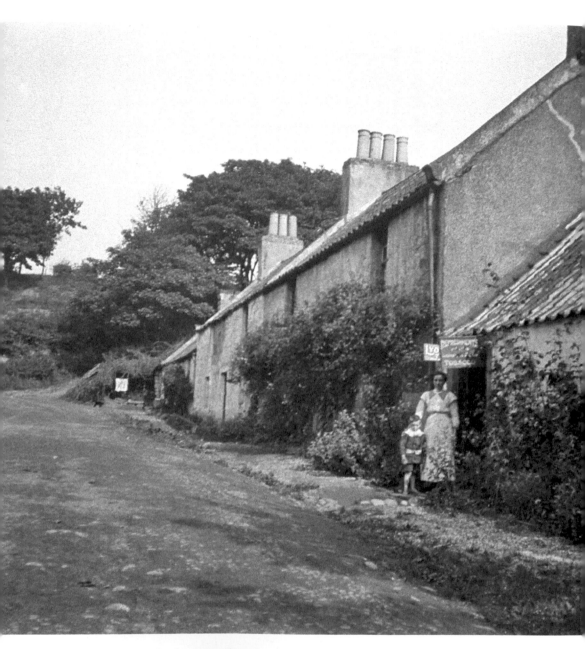

Crombie Point. In the sixteenth and seventeenth centuries, there was milling, salt manufacture coal mining and most probably limestone quarrying, as well as a sizeable area of cultivated land. Crombie Point also boasted one of the oldest smiddies in the country, and a reputable private school. This house was a shop at one time and, judging by the clothes of the woman and her son, I think this must be the oldest photograph of my great-grandfather's Crombie Point collection.

Merchants lived in Crombie Point and, in the mid-nineteenth century, a few houses were advertised in the *Dunfermline Journal* as available for let. When Capt. Inglis built Crombie Point House, some of the buildings on the left of the road were demolished.

Most of the houses date from the eighteenth century. A Miss Beveridge, the sister of the local historian David Beveridge, died in the top flat of the nearest house, having lived there for many years. The next two-storey house was the Black Anchor Tavern. A lot of 'underhand wark' was carried out between the Dunfermline wine merchants and the shop owners of Crombie Point, causing the hamlet to become known as a 'smuggler's nest'. Tam Martin, the notorious landlord of the tavern, was a key player in this smuggling trade.

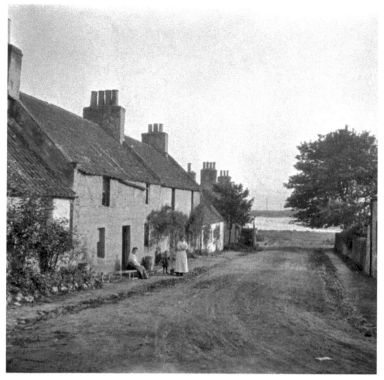

Looking down towards Crombie Point pier. In 1775, a pier was built to replace the old one at Torryburn. This pier was an unusual length, some 920 feet, which was probably to bring its head into as deep water so it could be reached. It subsequently became a busy port and, in the late 1700s, Robert Colville used it to export his coal, and the Dunfermline merchants used it to ship their wares to London via Bo'ness.

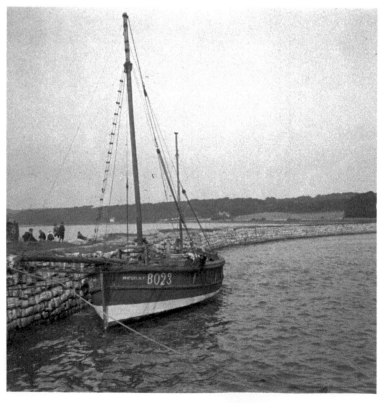

Crombie Point Pier. Capt. Inglis, who died in 1905, repaired the pier several times at his own expense. He was associated with the Hudson Bay Co. and owned a considerable portion of the village. Crombie Point was a passenger port, with ships calling on their way from Leith to Stirling. According to an advert in the *Dunfermline Journal* 1852, passengers were landed daily from the Alloa and Stirling steamers.

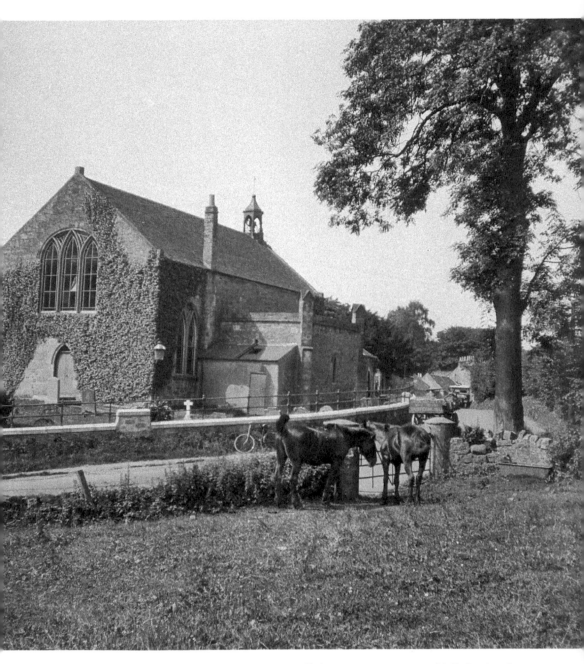

Torryburn. The parish took its name from the estate called Torrie (meaning conical hill place) and the burn that separated it from Craigflower. The parish church, situated in 'God's Little Acre', is one of the oldest buildings in the village dating from 1800. It was reopened after reconstruction in 1929, so this photograph dates from before 1928. There is evidence of an earlier seventeenth-century edifice, and it's probable that a kirk was here as far back as 1481. The church is now closed and may be used as a community centre. The cart belongs to John Bisset, the Dunfermline lemonade company.

When it was decided to widen and improve the main street, many of the old buildings that had fallen into disrepair were demolished and replaced in 1961 by council houses. One of the remaining flats in this street was the birthplace of R. L. Stevenson's nurse, Alison Cunningham, in 1822. Affectionately known as 'Cummy' by the author, he later referred to her as the 'angel of his infant life'. She died in Edinburgh in 1913.

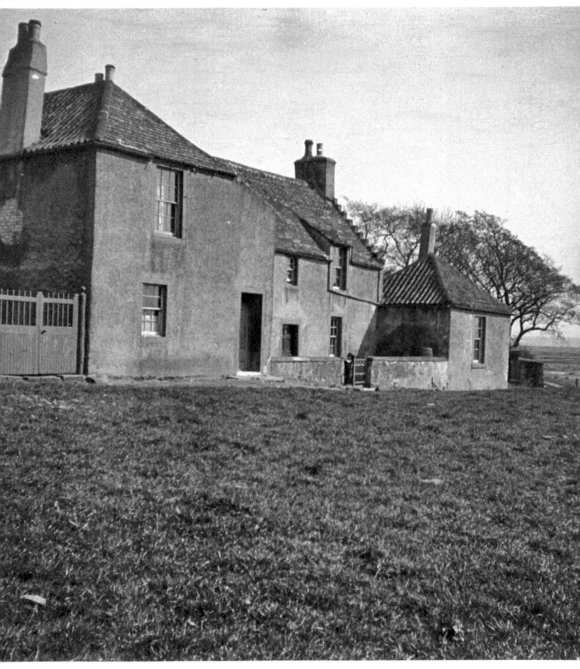

This large house, situated in The Ness, has now gone and an electric street lamp has replaced the gas one. During the nineteenth century, the lovely bay from Torryburn to Culross was dotted with the summer residences of affluent Dunfermline merchants and businessmen. It was quite the holiday resort. With its 'auld pier', Torryburn was a busy shipping port for a time. It was also a very quiet place – in the 1890s, the village policeman was a cobbler by day!

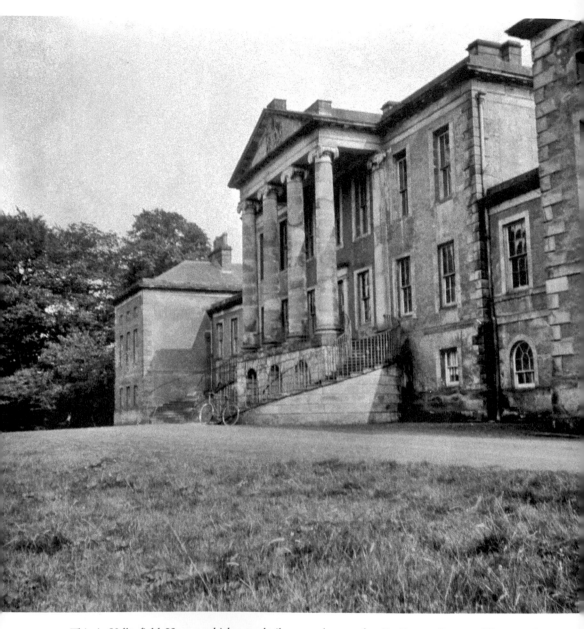

This is Valleyfield House, which was built around 1750 for Sir George Preston. His son, the merchant and philanthropist Sir Robert Preston, inherited the Baronetcy of Valleyfield in 1800. Known as 'Floating Bob', he made a vast fortune through trade with the East Indies. He was renowned locally for developing the saltworks and coal mines at Preston Island. Abandoned in 1907, the house was finally demolished in 1941. Metal was removed from the roof during the First World War, and since there is no sign of deterioration in the property, it would seem this photograph dates from between 1914 and 1918. Auld Jimmy's bike is propped against the staircase.

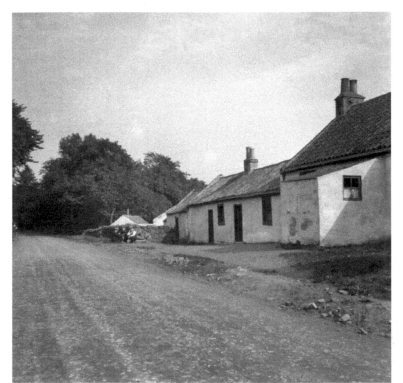

Saline. Muirside Cottage, on the A823 road to Saline, beyond Wellwood. Only the building behind the men still remains; a bungalow has replaced the old cottage.

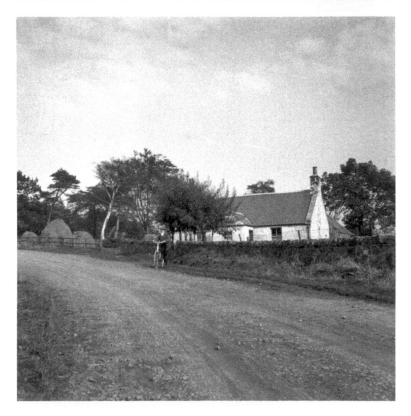

This cottage is on the B915 road to Saline past Lathalmond. It is now a semi-ruin.

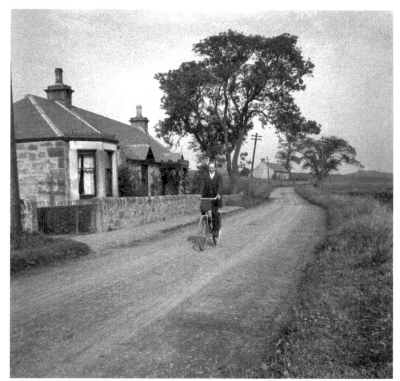

Looking eastwards along the B914 Dunfermline to Saline road (via Steelend). My grandfather travelled many places with Auld Jimmy, and here he is one of the rare occasions he wasn't wearing his 'bunnet'! Instead it's perched on the front of his bike.

Cowstrandburn. The cottage on the left has gone, with only part of a wall remaining. Maryfield House, as it was known on old maps, is on the right. It has survived today. This B913 is another road to Saline that Auld Jimmy must have travelled.

Saline possibly means 'little barn'. This relates to its early connection to the Scottish Crown; the barn being a place of collection and storage for local tribute due to the king. Around 1335, the village and parish were referred to as 'Sauelyn,' a name that many locals still use. The Mercers were a local stonemason family who built many of these cottages in Main Street, most of the village being developed in the eighteenth and nineteenth centuries. In the foreground is Auld Jimmy's trademark – his trusty bicycle.

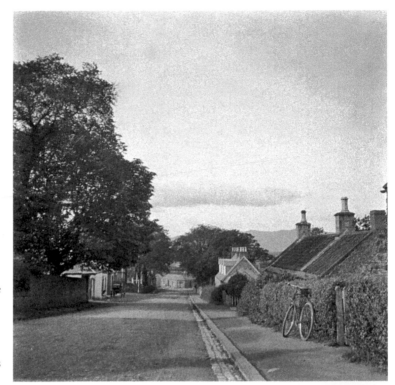

To the right at the crossroads of North Road and Bridge Street, is Drumcapie Place. Visible on the side of the first house is the date 1786. Saline was often described as the 'The garden or Paradise of Fife' because of its picturesque location.

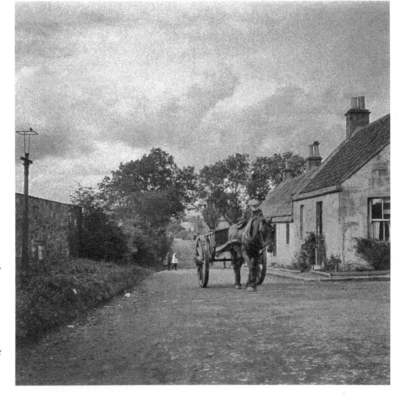

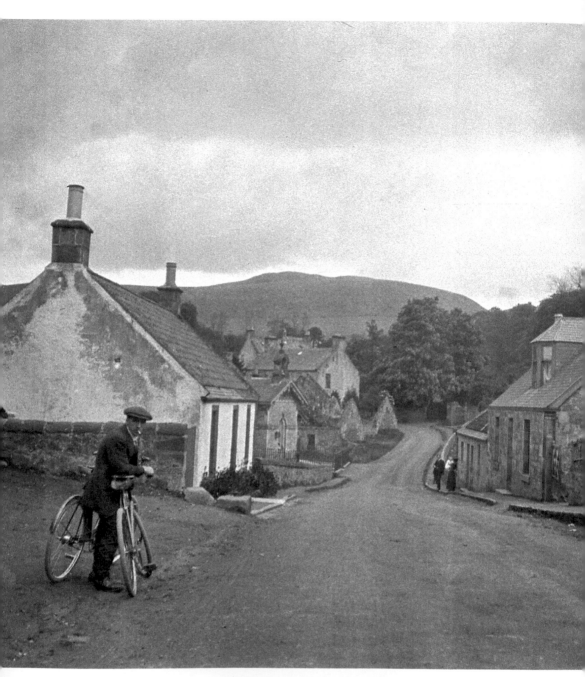

Bridge Street. At the turn of the century, when many a Scottish village was still torn with dissension between the 'Auld' and the 'Free' Kirk, there was harmony between the two congregations in Saline. The Free church on the left of this photograph was built in 1844 by Lewis Mercer. Saline was often frequented by Sir Walter Scott when he came to visit William Erskine at Nether Kinnedar. My grandfather is on the left, with both his bike and Auld Jimmy's.

Inverkeithing. A rear view of the Friary Hospitium, Queen Street, which belonged to the Grey Friars and dates from the mid-fourteenth century. It is one of the best preserved friaries in Scotland. When it was a lodging house, navvies employed on the Forth Bridge and Rosyth works stayed there. Between 1932 and 1935, A. J. Wilson restored the fourteenth-century detail of the Friary and retained the seventeenth-century detail. The walls were stripped of their harling and repointed. The three buildings to the right of the Friary have since been demolished to provide access to Friary Gardens and Friary Court.

Looking down Queen Street. Situated at the mouth of the Keithing Burn, the town is still known locally as Inverdivot. At the bottom of this street is the site of the old medieval south port (or entrance). The house with the forestair and wall mounted lamp is the Friary Hospitium. Annabella Drummond, Queen of Robert II, adopted the building as her small palace. The houses either side of the Friary have been demolished with the Inverkeithing Civic Centre now occupying the site to the right of it.

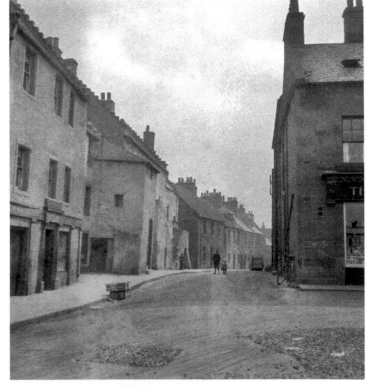

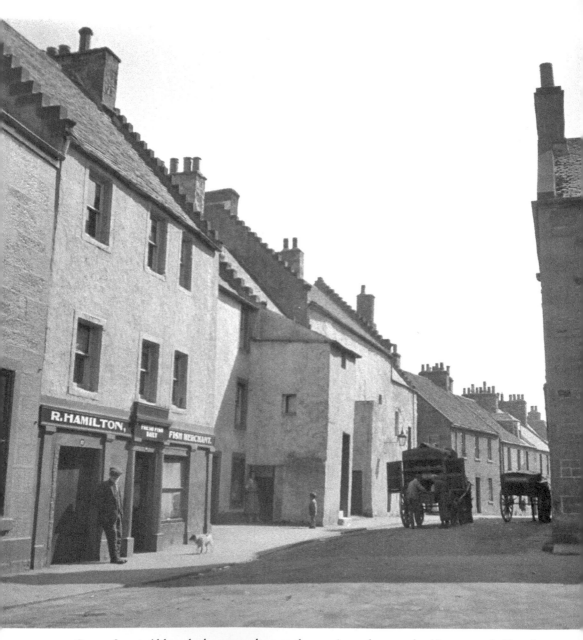

Queen Street. Although the same place as the previous photograph, this was probably taken at a later date, the shop on the left being open for business. Note the cart in the centre of the street beside the Friary. A number of Dunfermline traders ran horse-drawn shopping vans, to Inverkeithing, to sell groceries and bakery produce.

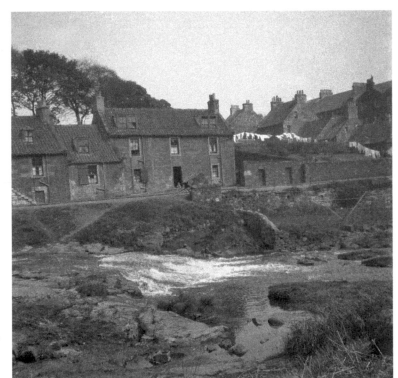

Waggon Road. Keith Place has replaced the old buildings in the foreground. The houses on Alma Street are visible to the right. The street derives its name from a Crimean war battle in 1854.

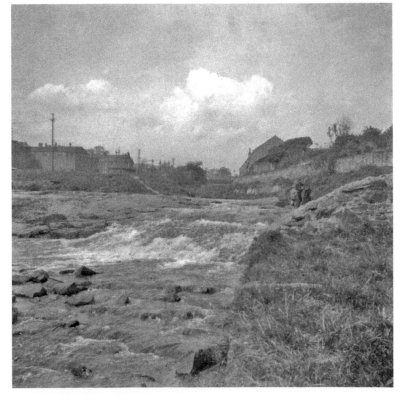

This shows the same area but looking in the opposite direction. On the left is the back of the Majestic Theatre. It was opened in 1918 by Mr and Mrs Lamb and closed in 1960. The building is now part of the Bargain Centre. Both photographs show an area of Inverkeithing that is dramatically different, with much of it having been reclaimed and used for parking and housing.

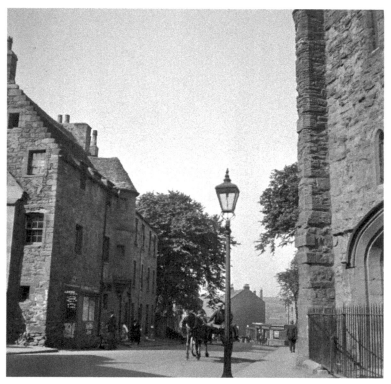

Church Street. The steep gabled building to the left of the turret is Fordell's Lodging. It was built by Sir John Henderson between 1666 and 1670 (The family was Hendersons of Fordell, hence the name). Horses and carts were a common sight due to the farms near the centre of the town. On the right is the entrance of St Peter's church.

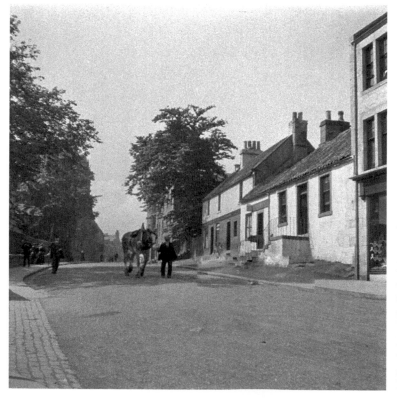

Church Street looking towards the High Street. One of Inverkeithing's most famous sons was born in what was once The Royal Hotel. Sir Samuel Greig (1735–88) grew up to become the supreme admiral of the Russian navy. This hotel was haunted by the ghost of a nun. A distinct aroma would precede her appearance – a sweet smell of roses if she liked you; a putrid smell if she didn't! The buildings down from Fordell's Lodging, on the right, have been replaced with modern housing.

Townhall Street. On the right is the distinctive Town House (or tolbooth). This was the collection point for burgh tolls or taxes. It also served as the meeting place of the burgh council, and as the burgh jail for debtors and suspected criminals. The first stage of the tower dates from around 1550. The second and third stages belong to 1754/55, and the main structure itself was rebuilt in 1770. The characteristic symbol of the burgh status is the market cross. The one in Inverkeithing dates from around 1398 and is one of the best preserved in the country.

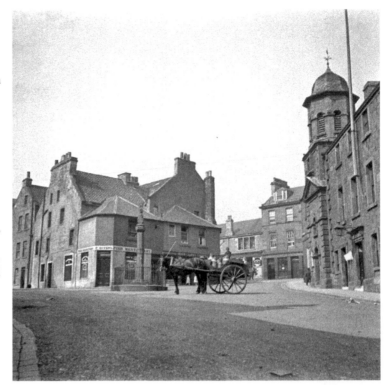

Looking towards Bank Street at the time of the fair. Inverkeithing was, at one time, a prosperous market town and this is remembered every year by Lammas Fair, held every August for the past three hundred years. The house on the left, Nos 2–4 Bank Street, dates from 1617 and is called 'Thomsoun's House', after John Thomsoun a burgess of Inverkeithing. The Mercat Cross used to stand in the High Street, but was moved to Townhall Street in 1799. It was moved again in 1974 to its present position in Bank Street.

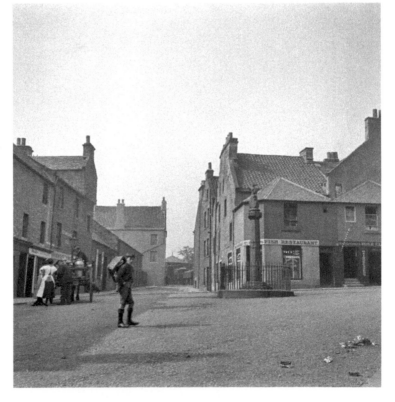

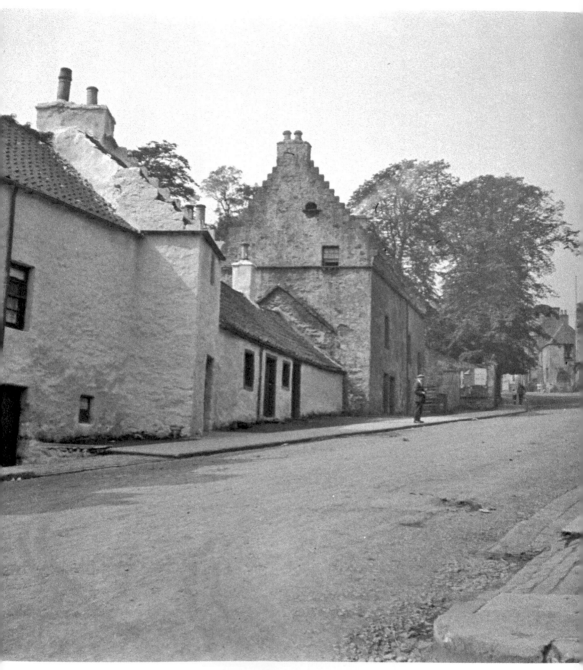

Looking up King Street towards Gallagher's pub on the right hand side. The buildings on the left have been replaced by modern housing. As a medieval town with its four ports, Inverkeithing must have been an impressive place, but fires through the ages destroyed a lot of its older wooden houses. There were fires in 1379, 1419–20, and after the Battle of Inverkeithing in 1651. Subsequently, a great deal of rebuilding took place in the late 1600s.

Preston Crescent and Inverkeithing Inner Bay. This bay would have been one of the finest natural harbours in the world, if not for the fact that, at ebb tide, it is left almost entirely dry. The villas that surround the bay were once the homes of retired sea captains and later occupied by paper mill workers. The last surviving captain of a sailing ship attached to Inverkeithing died in 1948. In the 1800s, there was a rope works at the south-east end of Preston Crescent. Much of this bay has been reclaimed and is now used for sports and the local Highland Games.

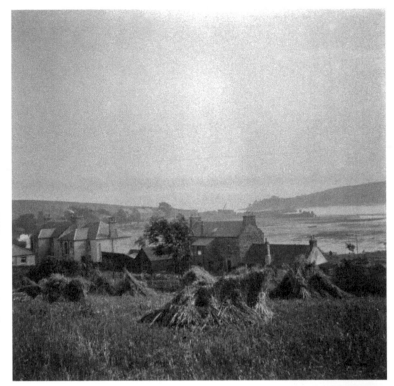

During the winter months, redundant herring drifters were a common sight in the bay. These Fifie Drifters came from the East Neuk of Fife. Inverkeithing harbour was the landing place for the Royals on their way to Dunfermline. It was also ideally suited for trade. Salt manufacture was one of the earliest industries, reference being made in 1286 to the manager of the King's salt pans.

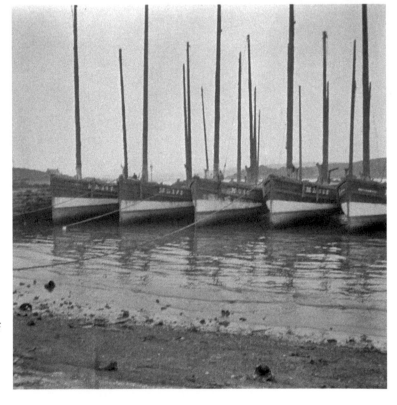

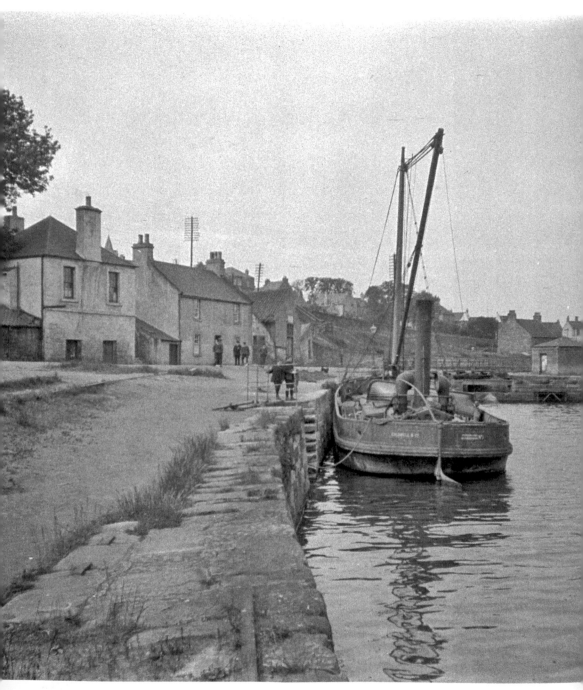

Harbour Place, Inverkeithing. Note the name on the side of the boat: Caldwell & Co. The company owned ships called mill 'lighters', which carried goods from both sides of the River Forth for further transport south by coastal vessels. The company established a good reputation for its white and tinted writing paper, and was one of the country's pioneers of greaseproof paper. The mill closed in 2003 and has since been demolished.

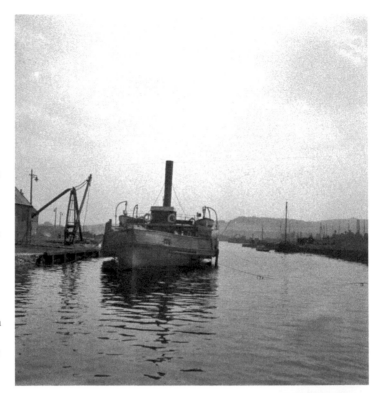

Harbour Place, around 1920. *The Woolwich*, which was built in 1890, was 100 feet long, and therefore able to handle vehicles all year round. She belonged to the Great Eastern Railway and plied the Forth from 1908. She was owned from 1908 to February 1919 by J. S. Wilson, and then until October 1919 by the Wilson executors. She belonged to the Leith Salvage & Towage Co., until broken up in October 1923.

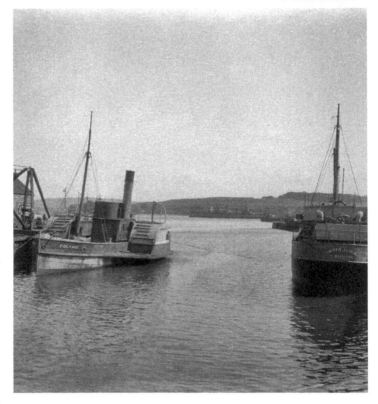

This photograph was taken in 1920. *The Dolphin* was built at Port Glasgow in 1885 and used as a Forth Bridge construction vessel. She was owned from 1890 to 1919 by J. S. Wilson, who used her on the Tay ferry service. After this, she passed to the Leith Salvage & Towage Co., before being broken up in 1920. *The Innisjura*, seen here on the right, was built in Alloa, registered in London, launched in 1913, and purchased by the Admiralty between 1915/16 for use as a water carrier and served time at Scapa Flow. She was sold commercially on 18 March 1920 and was wrecked in a gale off Loch Broom in January 1921.

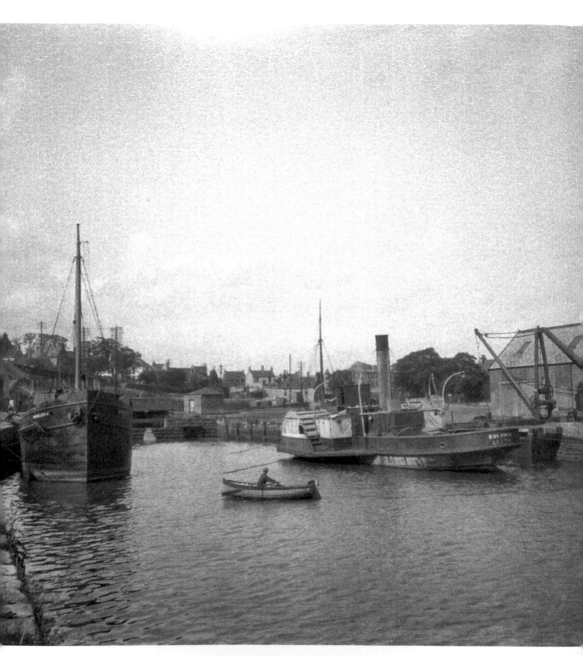

Harbour Place. The Keithing burn and its tributaries were once dotted with mills – a barley mill, a waulk mill and, before the time of Robert I, a windmill. *The Dolphin* is on the right-hand side. *The Innisjura*, which was built for the Coasting Motor Shipping Co. Ltd Glasgow, (managed by John M. Paton) can be seen on the left. Divers found the wreck off Loch Broom in 1994.

Harbour Place. The Woolwich can be seen on the right. Ward's shipbreaking yard was established in 1894 and, over the years, dismantled around 377 warships and naval craft. From 1922 onwards cranes were used to lift pieces of steel etc. weighing up to 50 tons, and load them on to trains. The scrap was then sent to blast furnaces, melted down and reused. Many famous ships ended their days at this yard: HM Ships *Nelson*, *Rodney*, *Royal Sovereign*, *Revenge* and the Cunarders' *Homeric* and *Cedric*.

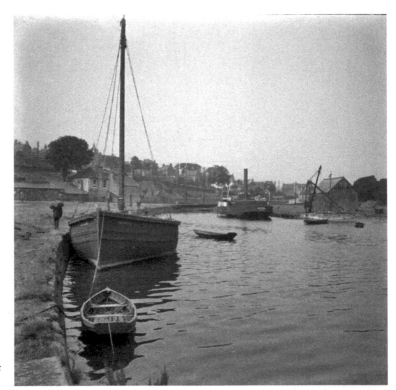

Industries around the harbour area have included shipbuilding and brick manufacture. In George III's time, Royal Navy ships sheltered in the harbour during winter storms. When Daniel Defoe visited Inverkeithing in 1726, trade was on the decline and, by 1758, Sir William Burrell found it to be a 'mean, miserable, paultry town'. Note the dog having a swim.

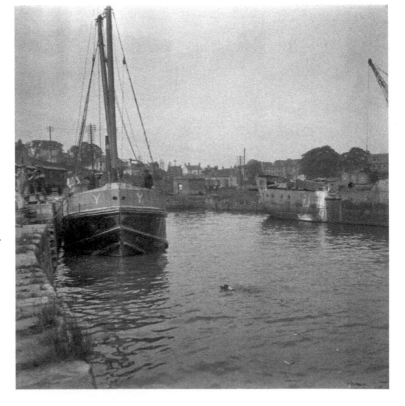

St David's Harbour. This photograph shows a rear view of the houses on the pier. On the left is the office and house of the shipping agent. The Fordell wagon way stretched for a distance of five miles from St David's to just south of Cowdenbeath and was in use longer than any wagon way in Scotland. When the railway closed in 1926, it spelled the end of St David's as a coal port. In 1947, James A. White the ship breakers, took over the harbour in conjunction with their main yard in Inverkeithing. In the 1990s, this area was redeveloped with attractive houses and flats.

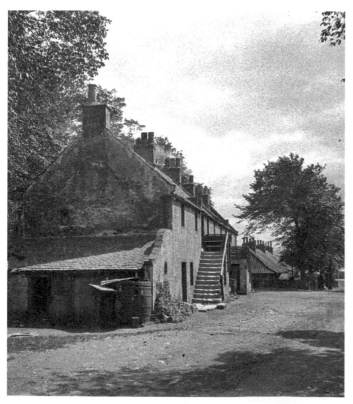

Looking south towards the harbour. Most of the cottages on the left were demolished in the early 1950s. A big thank you to my Mum's cousin, Mary Cook, for helping me finally identify this photograph.

Chapter 4

A Journey to the East

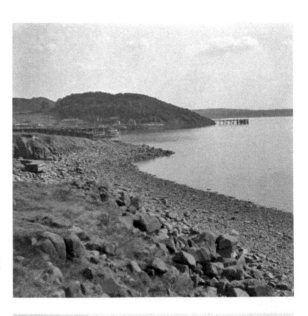

St Margaret's Hope is a bay that lies between Rosyth Castle and North Queensferry. Margaret, landed here with her brother, Edgar Atheling, and sister, Catherine, in 1068. After fleeing the English court and the repercussions of the Norman Conquest, she found sanctuary with her future husband, King Malcolm Canmore, in Dunfermline. The word 'hope' described a place where ships could lie at anchor in safety. The bay was an important shipping anchorage until the Rosyth Dockyard became fully operational in 1916. The jetty in the photograph was owned by the Tilbury Co.

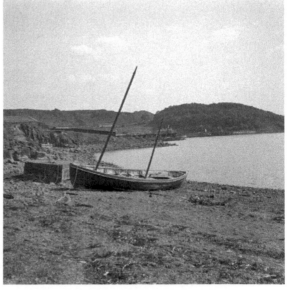

Whinstone, transported from this bay, had been quarried in the area since the 1820s, and used in the building of Leith and Liverpool docks as well as the pavements of London. Deep Sea World is an old whinstone quarry. Much of this land has been reclaimed and looks very different from the days of Auld Jimmy, especially with the Forth Road bridge opening in 1964, and all the present land work associated with the Queensferry Crossing scheduled for completion in 2016.

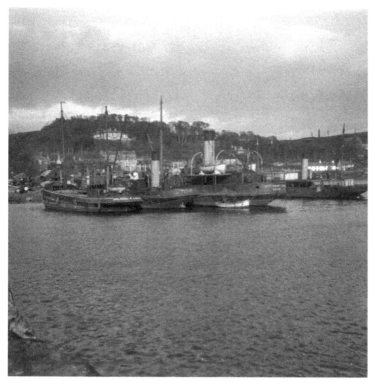

North Queensferry. This has been taken from beside the Railway Pier looking towards Northcliff – the big house on the hill. Dating from 1877, the Railway Pier was used by the ferries until 1964. The Forth Road Bridge was officially opened by the Queen on 4 September 1964, and the ferry boat days came to an end. A local who had worked on the construction of the railway bridge, was asked what he thought of the new road bridge and replied, 'It'll be a nice bridge when it's finished, but it'll never beat ours!'

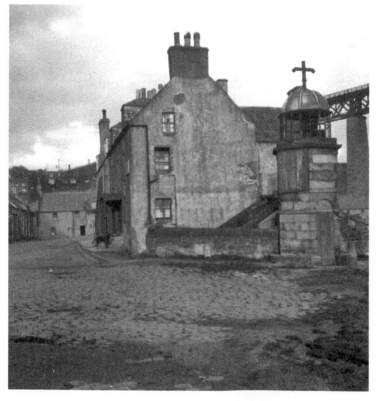

The first real ferry service was initiated by Queen Margaret for the benefit of pilgrims to St Andrews. She charged a penny a trip, but allowed free passage to the pilgrims. As the ferry flourished, so did the community that grew up around it. Many of the old houses around the pier and the tip of the peninsula, were condemned and had to be demolished. The house in the foreground, with the outside stair, has gone. The Lantern Tower, on the right, was built by John Rennie. Dating from 1810 to 1812, it was a key part of the Queensferry Passage. It has been restored and was reopned to the public in 2010.

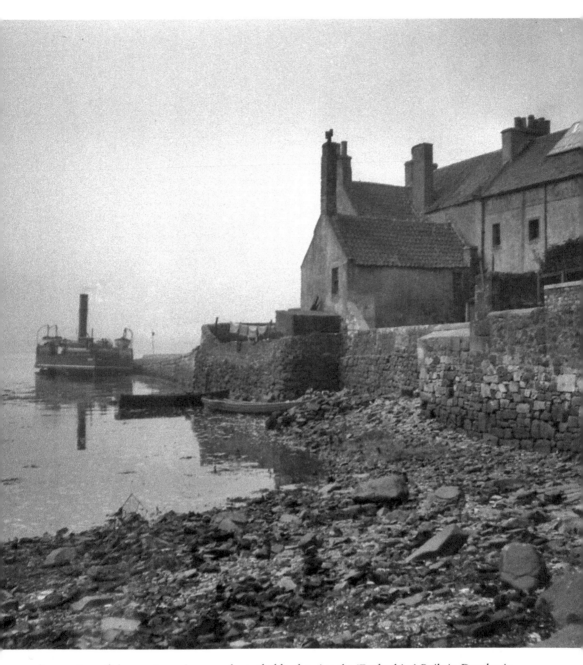

A rear view of the previous photograph, probably showing the 'Forfarshire' Built in Dundee in 1861, it was broken up in 1922. The town pier was built between 1810 and 1813 by John Rennie, and extended from 1828 to 1834 by Thomas Telford. The ferries plied between here and South Queensferry. In the 1800s, North Queensferry had thirteen inns ,and old records show that a considerable quantity of ale and beer were brewed in the village. Note the advertising sign on the roof of Pierhead House. This was aimed at those travelling over the Forth Bridge.

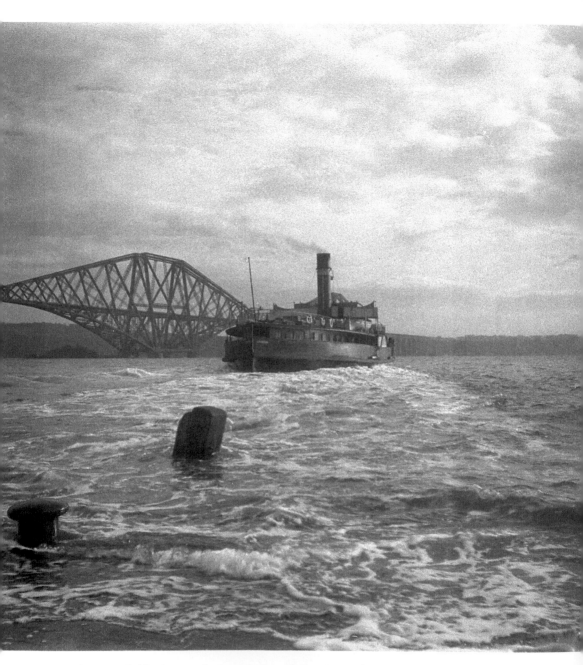

This is probably the *Dundee* leaving the railway pier. Built in 1875, the boat was in operation from 1920 to 1947, and broken up in 1952. To quote Donald Macdonald's article in *The Scotsman*, dated 31 May 1962, 'Princes and paupers, lairds and peasants, shepherds and bakers – even cows, camels and 'Jumbo' the elephant have all crossed the Firth of Forth by ferry.' The latter refers to an incident in 1899, when it took from 10 p.m. to 4 a.m. to ferry George Sanger's circus across the Forth. The famous artist Sir John Lavery was arrested while painting the Grand Fleet in the Forth in 1917, and was asked to produce his permit, while local kids taunted him by shouting, 'The German spy painting oor brig.'

Aberdour. This village that sits at the mouth of the Dour Burn was first mentioned in old records, when reference was made to the barony of Aberdour acquired by Sir Alan de Mortimer in 1126. Auld Jimmy's son-in-law was a carting contractor among other things, and one day decided to treat family and relatives to a day's outing to Aberdour. Here they are in the Main Street, just up from the Woodside Hotel. The flags suggest it was the time of the Regatta.

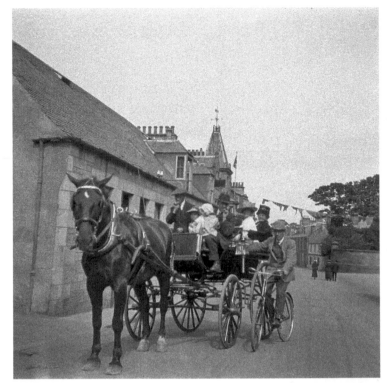

Manse Street. Note the 'For Let' signs in the photograph. These were properties available for holidays. With its traditional industries in decline, by the 1850s Aberdour's fortunes lay with tourism. According to Black's *Picturesque Tourist of Scotland*, dated 1856, 'Aberdour is protected from the east wind by a noble cliff called the Hawkcraig and has a warm southern exposure.' Because of its favourable situation, Aberdour became a popular destination for Fife and Edinburgh holidaymakers, especially during the First World War.

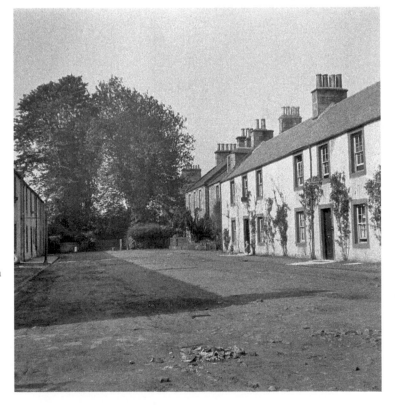

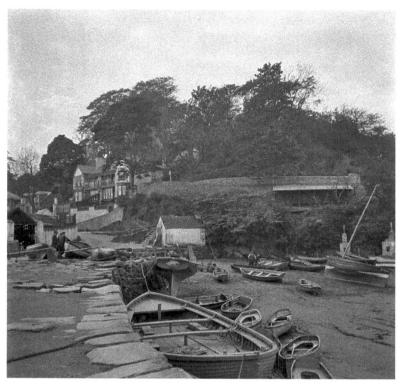

Looking up towards Shore Road. The building on the near left is now the Aberdour Boat Club. The white hut opposite has been much transformed and is presently a gallery/gift shop.

Aberdour has always attracted people – St Fillan's drew pilgrims and the infirm. The famous writer, Thomas Carlyle, wrote part of his book, *Frederick The Great*, in Humbie farmhouse and, with the advent of rail travel, holidaymakers began arriving. Today, the houses of Hawkcraig Road dominate the background.

Steamers travelling back and forward to Leith and Granton used to call regularly at this stone pier until the start of the Second World War in 1939. The harbour was also used for the shipment of coal, salt, limestone and sandstone.

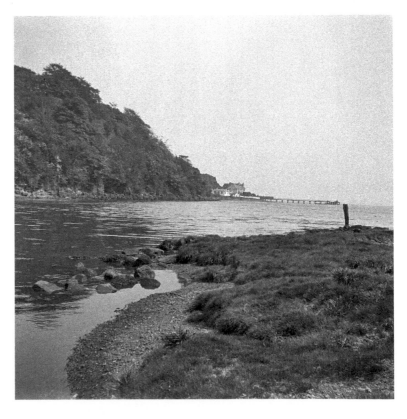

Looking towards Hawkcraig Point and the old wooden pier, built in 1866 for the use of ferry boats at low tide. The Forthview Hotel, just visible at the far end, was built in 1880 and originally known as Bleakhouse. It became a hotel in 1881 and was renowned for its salt spa baths.

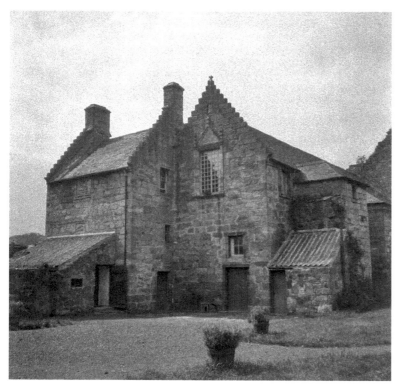

Aberdour Castle represents four distinct building periods, dating from around the twelfth century to the seventeenth century, with the oldest part being the hall house, or keep. The east range seen here, was built in the seventeenth century. The castle was occupied by three noble families over 500 years – The Mortimers, Randolphs and Douglases.

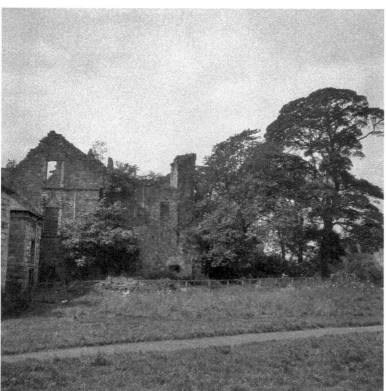

This shows the ruin of the central range, which was added to the castle in the sixteenth century to replace the earlier three-storey tower house. The castle was taken into state care (the present-day Historic Scotland) in 1924, and so these photographs probably date from after that. Note the 'chooks' in the foreground.

Otterston Loch. Located off a minor road near Dalgety Bay, the loch takes its name from a Scandinavian word meaning 'Other's Steading'. These bonnie cottages are now in a ruinous state.

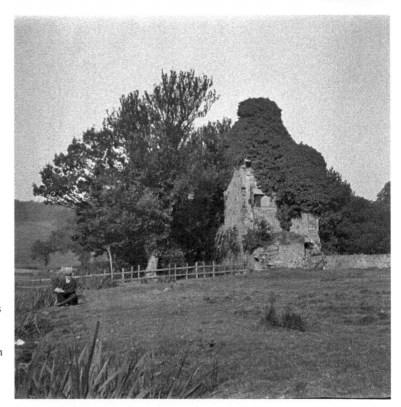

Near the south-east corner of the loch can be seen the few remains of Couston Castle, which was strongly fortified in the sixteenth century. The castle was restored in 1987 by Alastair Harper.

Chapter 5

Man's Labour in the Fields

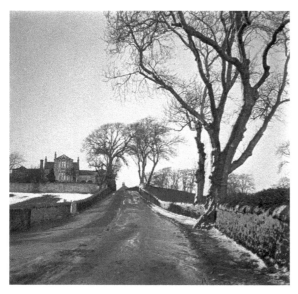

Looking towards Urquhart farmhouse. In 1892, Dunfermline Co-operative Society obtained the lease of Urquhart and Logie farms from Colonel Hunt of Pittencrieff and for a while, Urquhart was one of the main milk suppliers in the area.

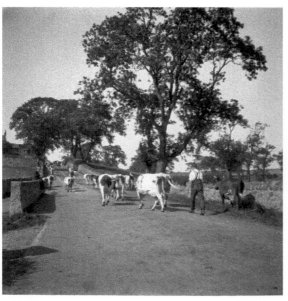

In 1850, Urquhart farm played a part in what was known as the Irish Eviction. Irishmen working in Dunfermline accepted low wages, thus depriving many locals of jobs. The growing hostility towards the incomers was further fuelled by the over celebration of a 'Navvy's Farewell'; the Irishmen's night on the town ending with a fight that caused considerable damage. On the Monday morning, Irishmen, hoeing a field of potatoes on Urquhart Farm, were confronted by locals. The townspeople were now determined to evict all Irishmen from Dunfermline, even those that had lived and worked in the town for years. Herding them down to North Queensferry for the trip across the Forth, the Sheriff Officer and his men intervened in time, and the Irish returned to Dunfermline.

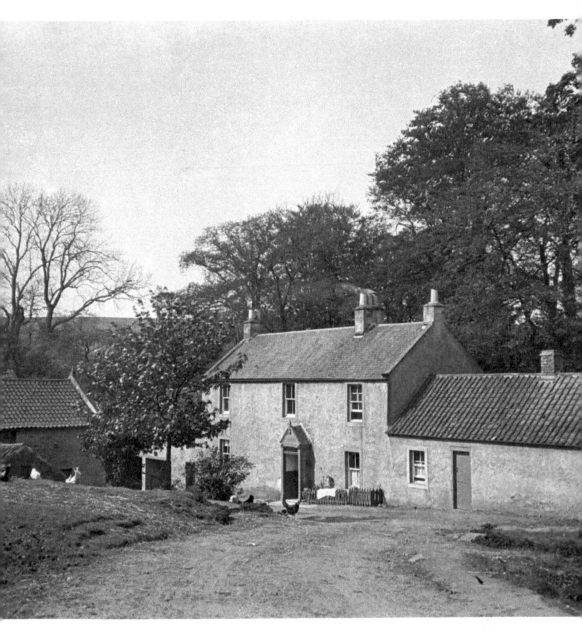

Woodmill Farm, Woodmill Road. The house is now a C listed building and mainly dates from the late eighteenth century. Its situation among the trees has changed little. The major transformation around this farm has been in the surrounding countryside. The hill to the left is now built up, with the housing schemes of Garvock and Touch. The busy Woodmill Road and Abbey View houses lie close by to the south.

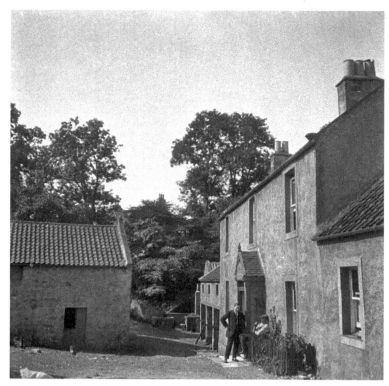

The farmhouse's appearance has changed slightly over the years, Auld Jimmy having captured his own 'then and now' scene. The bottom photograph is possibly the later one. Note the outside staircase. The chimneys in the background of the top photograph belong to a house known on old maps as Bonnyton.

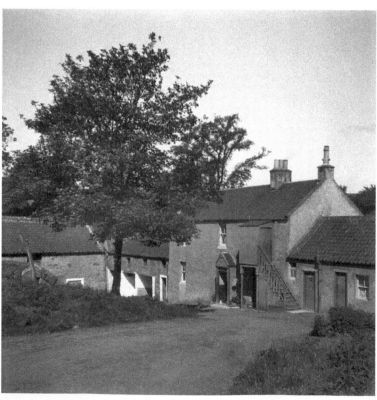

The environs of Woodmill Farm. The farmhouse was part of a group of early buildings, including a corn mill, which lay to the south of the house. The grain for this would have been stored in the upper floor of the whitewashed cart shed, seen in the centre of the top photograph. The farming photographs that follow in this chapter were probably taken around Dunfermline.

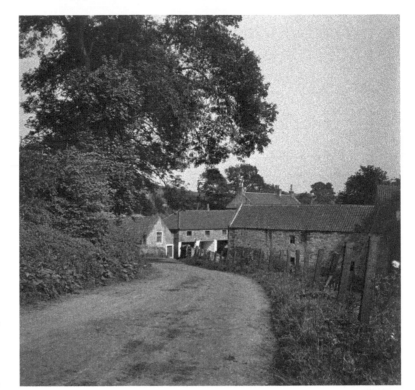

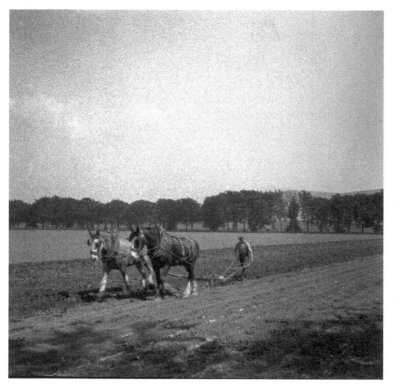

The Hand Plough. According to an old farmer, there was no work more pleasurable if the sun was shining, the larks were singing and the plough was moving well. Ploughing matches were once popular throughout Fife. The old Scottish plough, with its team of up to twelve oxen, needed two men to work it, but the new lighter ploughs needed only two horses, which came to be controlled by reins. This was partly made possible by the stronger, better breed of Clydesdale horse.

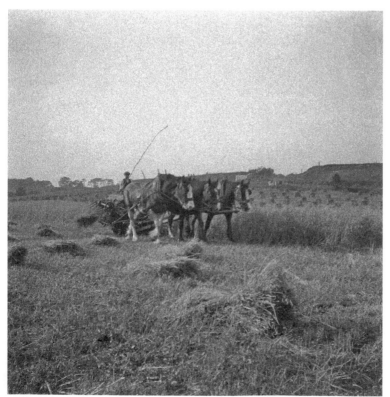

This photograph, and the following two, show three horses pulling the Hornsby Binder, which was used before the introduction of the Combine Harvester to Scotland in 1932. The binder cut the corn and tied it into bundles, or 'stooks'.

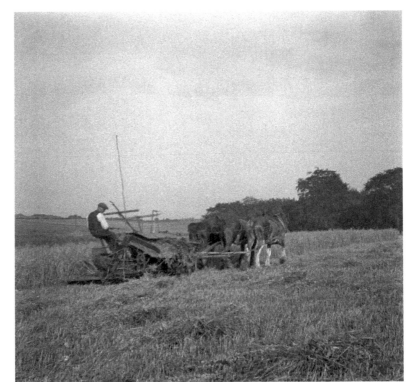

From 1910 to 1950, Fife was one of the chief producers in Scotland of oats, wheat and barley, as well as the common crops of potatoes, turnips and swedes. Fife has remained one of the most important agricultural counties in Scotland.

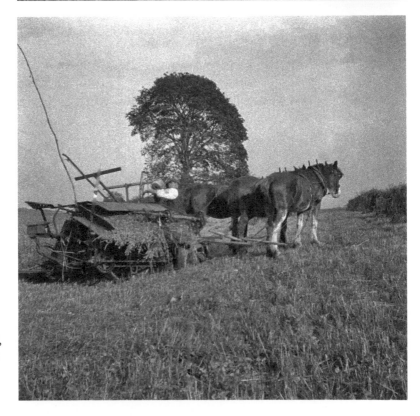

Clydesdale horses were widely bred in south-west Scotland, and sold at the start of February each year at places like Lanark fair.

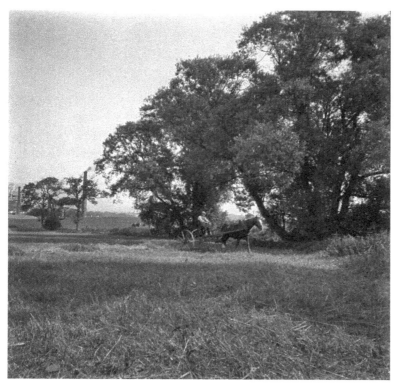

The Horse Rake. After the binder had done its work, the rake was taken round to gather up any corn that was left. Looking towards Elgin Street, the chimneys in the background belong to the Rubber Works, and the furthest away one, is that of the Bothwell Works. This area today is built up with the Elgin Industrial Estate. There is also farming work going on in the field beyond.

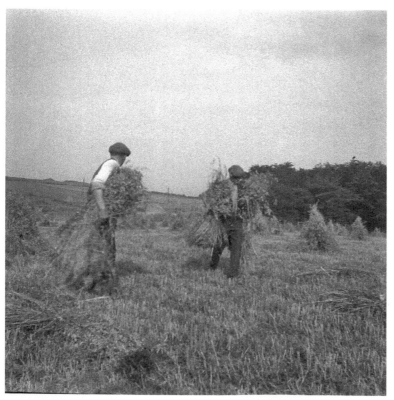

Gathering in the stooks. To prevent mould developing, the stooks had to be dry before they could be stacked. The farmer usually propped six together and, if it was a windy day, he would lay the bundle of stooks down allowing the wind to blow right through. An old farmer remarked to a friend outside church, one blustery Sunday, 'Aye, it's a fine day to coup the stooks on their erse'. Once the stook was dry inside, up to the twine that bound it, it was carted away.

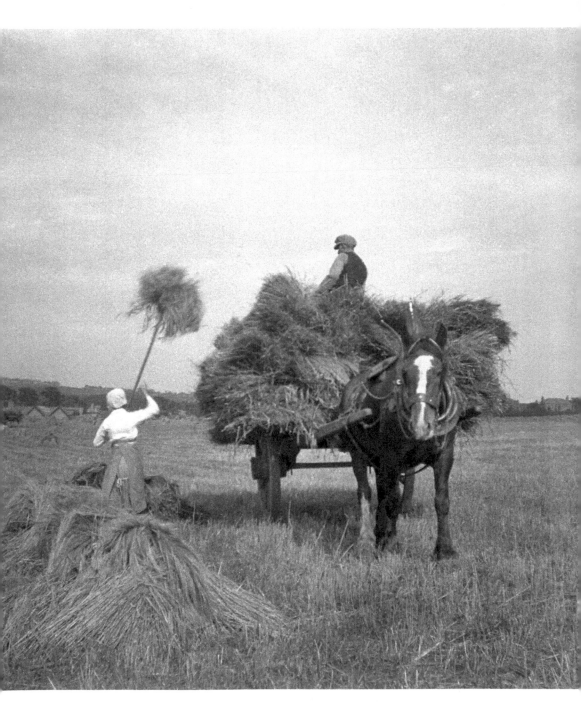

This, and the following two photographs, show gathering the stooks on the Grange farmland. Note the distinctive roof of St Leonard's school on the left and the houses on Garvock Hill behind it. St Leonard's School was built 1900–02, at a cost of £8,500, and was opened by the Earl of Elgin. These photographs were obviously taken prior to the building of the Dunfermline High School in 1939. This field is now dominated by the new Dunfermline High, opened in 2012.

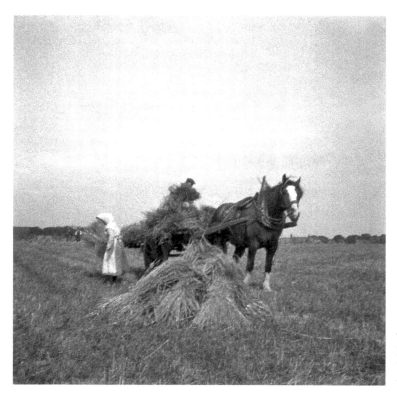

The houses of Hospital Hill can be seen in the background of both these photographs.

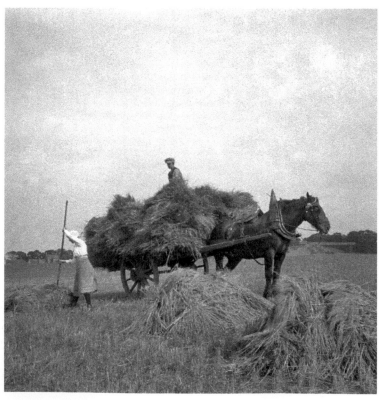

The Jenny Rennie's Road/Izatt Avenue housing scheme was built on these fields in the 1940s. St Leonard's Hill can be seen on the right.

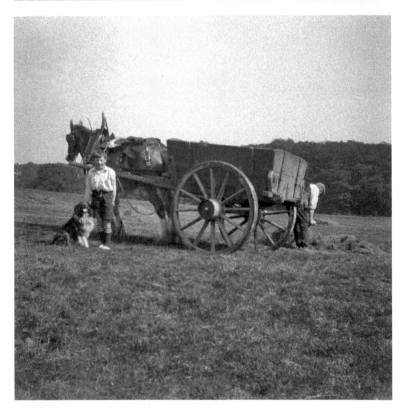

The sheaf cart is the subject of these two photographs. Harvest was a particularly busy time on arable farms and many helping hands were needed. The stooks were gathered up and loaded on to the carts, ready to be taken to the stackyard. This photograph may have been taken on the Grange farmland.

One lad and his dog.

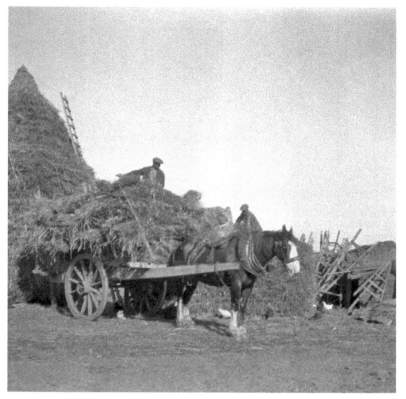

This photograph, and the following three, show stacking the corn. A farmer usually constructed his stack on a base of branches, or purpose-built wooden frames (visible to the right) to ensure good circulation of air. As the chore progressed, a 'striddler' aided the builder on the stack, while a man on the ground used a stackbeater to knock in any protruding ends of sheaves.

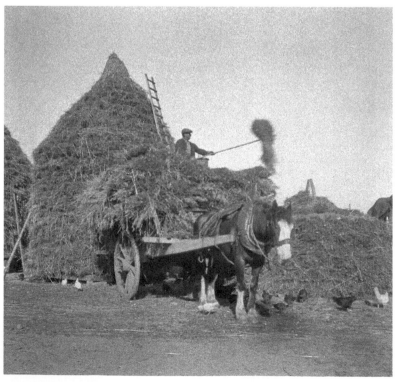

The ability to stack corn neatly, and keep it off the damp ground to prevent the harbouring of rats and mice, was always a recognised skill of the farm worker. Throughout the country, stacks varied considerably in shape and size. When the last sheaf or 'croon', topped the final haystack, it was an occasion to celebrate with whisky – an arduous task had finally come to an end!

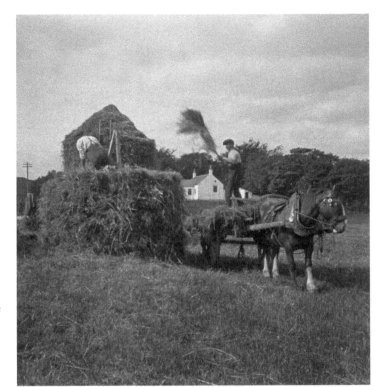

Modern machinery has done away with the need for stooks in the field and stacks in the stackyard. The days when man's labour in the fields inspired artists such as Millet, Van Gogh, and my great-grandfather, have long gone.

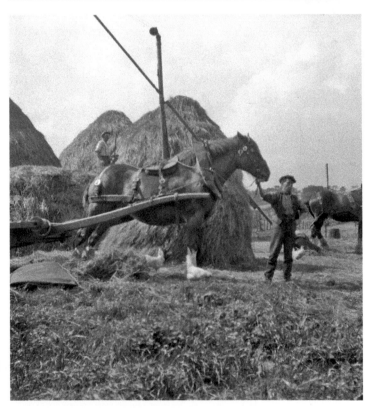

As mentioned in the introduction, my great-grandfather saw photography not just as a means to an end. He painted many of the wonderful scenes he photographed.

Chapter 6

First World War Soldiers in Dunfermline

The following photographs are the most interesting and oldest of my great grandfather's 2x2 negative collection. The First World War was triggered by the assassination of Austrian Archduke Franz Ferdinand, on 28 June 1914, in Sarajevo. Britain declared war on Germany on 4 August, after the Germans invaded Belgium. Soon after this, Dunfermline became more like a garrison town. The soldiers that mainly feature in Auld Jimmy's photographs were from the 9th Battalion of the King's (Liverpool Regiment).

This battalion was recruited from the Everton district of Liverpool, with a detachment based at Ormskirk producing some of its best fighting men. Its recruits came from all walks of life – sailors, miners, tradesmen, artisans – with officers drawn from professional classes and businesses.

On 4 August 1914, a telegram to Headquarters contained one word: 'Mobilize'. On 13 August, the battalion boarded trains at Lime Street station, Liverpool without a clue where they were heading. That afternoon they arrived in Edinburgh and continued on to Dunfermline, primarily to man the Forth defences in fear of a possible German invasion.

On their arrival, supper was provided by the good ladies of the town, after which the battalion was billeted in Transy. During the following weeks, they were moved to The Carnegie Institute, St Leonard's, the technical schools and the workhouse.

Auld Jimmy may well have latched on to this battalion after they assembled in Maygate, where he had his shop. After photographing the men, perhaps he asked if could follow the soldiers around taking more photographs on the way. Certainly photographers would not be a common sight back in those days and the soldiers may have wanted their presence recorded while someone was at hand to do it. Maybe even copies were sent to loved ones back home. Who knows?

Surprisingly, little was written in either the *Dunfermline Press* or the *Dunfermline Journal* about the battalion's time in the town, but one interesting item of news did make the *Dunfermline Journal*, 5 September 1914.

MILITARY FUNERAL IN DUNFERMLINE

The first military funeral in Dunfermline since soldiers arrived in the city, took place on Tuesday when Private Arthur E. Tollett, 9th Kings Liverpool Regiment, who died of pneumonia at the end of the week, was buried. He had been quartered in the clinic where he had received the most skilful of attention and after death the body was on Monday removed to Holy Trinity Church. On Tuesday a funeral service was held in the church, Rev. L.O. Critchley officiating. The scene as the cortege passed through the

streets was most solemn and impressive. The bugle and brass bands of the regiment headed the procession followed by a small firing party. Rev. L. O. Critchley in his white robe made a conspicuous figure and behind him borne on a transport waggon drawn by two horses came the coffin containing the remains draped with a large Union Jack on top of which lay the beautiful floral cross and deceased's bayonet and bandolier. On each side of the carriage walked the bier carriers including two brothers of the deceased also in the regiment and bringing up the rear were the remainder of the ninth company. The funeral was conducted with full military honours and included the 'Last Post' and three volleys discharged by the firing party. The officers present were Lieutenant Colonel Lloyd, Major Clark, Captain Paris, Lieutenant Fulton and Dr. Barnes all connected with the 9th Kings.

No doubt Auld Jimmy watched this funeral with sadness. Perhaps Arthur E. Tollett appears in his photographs.

In October, the battalion left for Tunbridge Wells (where their training programme continued), possibly sad to leave Dunfermline, where it was recorded that the folk were very kind to all the battalion. Almost every night, each man was invited to visit newly formed friends. On 12 March 1915, the 9th King's (Liverpool Regiment) set sail for France from Southampton. Many of these men would never return.

Auld Jimmy's sister was the wife of Sir George McCrae, who became famous for his First World War battalion, the 16th battalion Royal Scots (Lothian Regiment). Quoting from the *Dunfermline Press* of 5 December 1914:

It is the special desire of Sir George McCrae who has family and ties with Dunfermline, that a company of one hundred men should be raised in the city for his battalion.

A recruiting office was opened at the corner of New Row and Canmore Street. By a sad twist of fate, the first fatality in McCrae's Battalion was Robert Russell, the grandnephew of James' and Sir George McCrae's late wife, Lizzie. He was killed by a shell while asleep in his dugout, on 28 January 1916, having only been in France for three weeks. He was buried at Bois Grenier.

Sir George McCrae sent a letter to Robert's mother, a copy being published in the *Dunfermline Press*, 5 February 1916. Written in France, it was dated 29 January 1916.

Dear Mrs Russell,

We have had a very severe experience in the trenches and I cannot say how grieved I am to have to tell you that your boy has fallen in the fight.

It will be some consolation to you to know that he did not suffer any pain, as his death was instantaneous.

It took place yesterday afternoon. He had done his turn in the front line fire trenches and was resting in his dugout in the reserve trench when a large shell burst into the parapet.

We laid him to rest tonight, as the evening shadows were falling, in a quiet churchyard in the zone of fire, and we were left undisturbed. The Rev. James Black, our chaplain, conducted a short service, and we have reverently marked his last resting place, where he lies beside officers and men who have fallen.

I can fully sympathise with you in your great sorrow. As you know, I lost my eldest boy in the Dardanelles, and another son was severely wounded in France, so no one can know better how hard it is to bear and how difficult it is to understand, how our dear ones should be taken.

If you have lost a dear son, we have lost a gallant comrade, who had made himself loved by all.

He had made himself such a good soldier that he had been marked out for promotion at the earliest opportunity.

Please accept the sincere sympathy, of the officers and men of the battalion. We pray that strength may be given to your husband and yourself to bear bravely your sore bereavement.

Yours sincerely,

George McCrae.

An example of a letter that would be received by so, so many relatives of other fallen men.

This photograph, taken in the Public Park, alerted me to the 9th King's Regiment – its name discernible on the barrel. The barrel may have been filled with water for the horses.

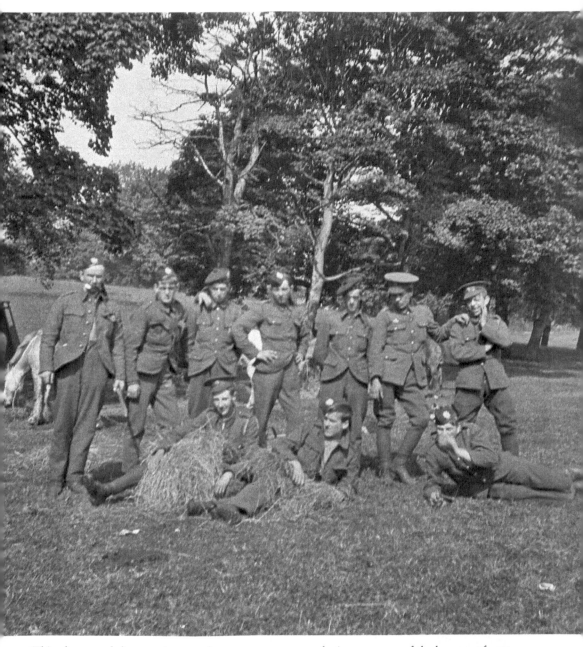

This photograph has a poignancy for me – young men relaxing unaware of the horrors of war that lay ahead. Those with peaked caps are 9th Kings' soldiers and the others, most probably, Black Watch Reserves. Six companies of Highlanders were recruited by their clan chiefs to provide a military style police force, or 'watch', in 1724, in response to the 1715 rebellion and recommendations of General Wade. The force became known as The Black Watch because of its dark green government tartan.

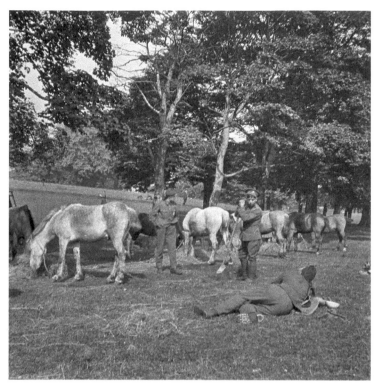

A soldier is seen wearing a Black Watch kilt behind the horse on the left. The Black Watch soldiers that appear in the Public Park photographs are most probably those of the 1/6th Perthshire Battalion (T. F.) The cap badges, although difficult to distinguish, are certainly the right shape for those of the Black Watch and, according to E. A. James in his book, *British Regiments 1914–1918*, Black Watch reservists were sent to Queensferry as part of the upper Forth defences, on 6 August 1914.

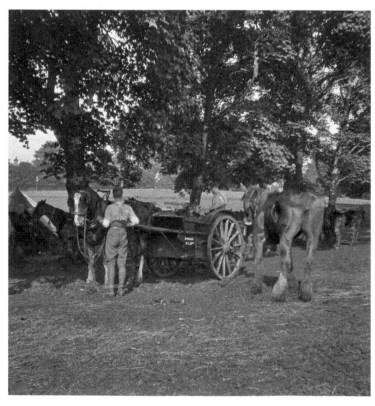

Note the bivouac tent in the background and the carts of the 9th King's. This again is taken in the Public Park.

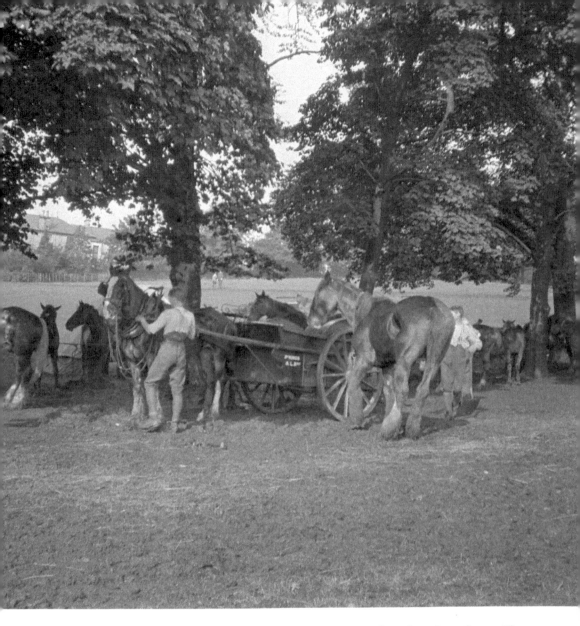

The big house on the left is No. 16 Comely Park, presently The Comely Park Business Centre. The 9th King's soldiers and their horses are standing on what is now the busy St Margaret's Drive.

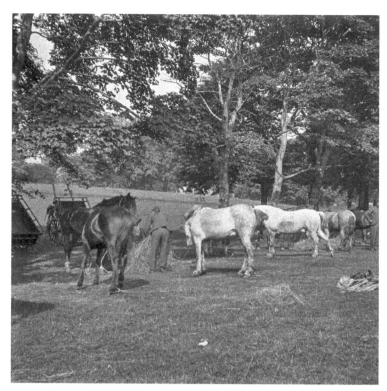

This, and the next two photographs, taken in the Public Park, show the horses being fed by the Black Watch soldiers. The horses have been tethered by one leg. This was known as 'hobbling'.

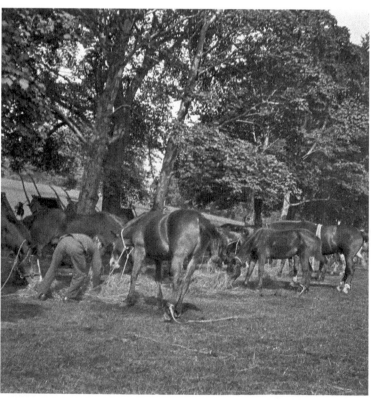

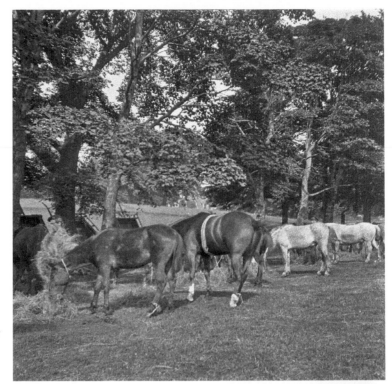

During the Second World War, the British Army deployed more than a million horses and mules. Thousands more had to be shipped from North America to meet demand. They were used to move ammunition, general supplies and ambulances. Some were ridden into battle. Many of these loyal animals would perish on foreign fields.

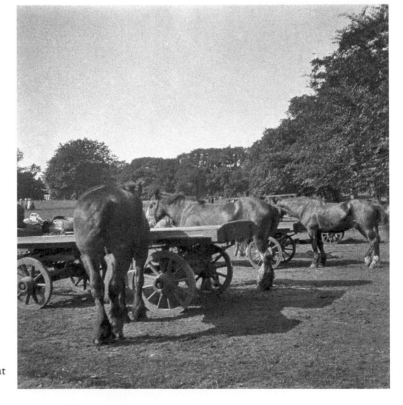

Note the ladies (*centre left*), in their long dresses, and the child sat on the nearest cart. It must have been a great novelty having so many soldiers in the town. Who could have foreseen the consequences and longevity of the war that had just been declared?

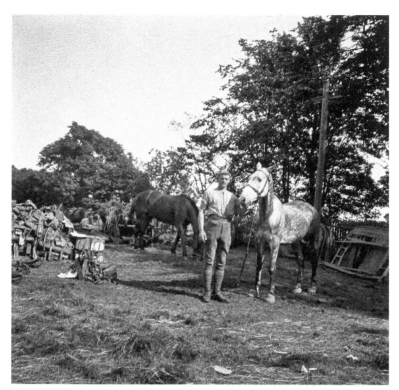

This photograph and the one below shows a pile of saddles and harnesses. This lad was probably in charge of the tack.

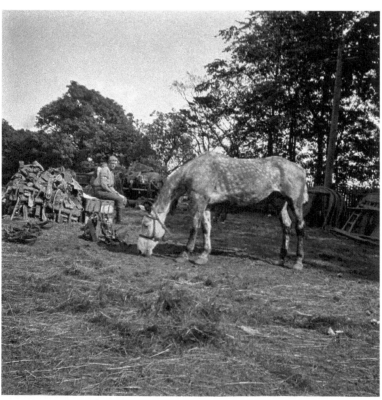

A bivouac with the town clock visible in the background. Perhaps this has been taken in the Urquhart/Logie Road area. Auld Jimmy's shadow appears in the foreground.

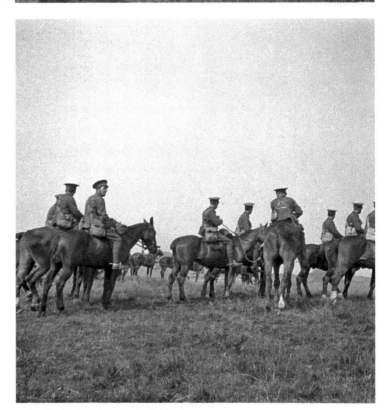

The 9th King's out Berrylaw way. The horses in the background look to be joined together by harnesses, probably ready to pull something heavy.

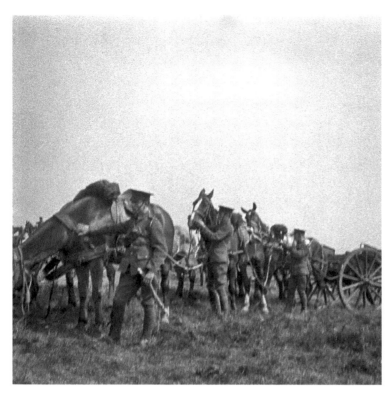

The horses in this photograph are seen harnessed to a limber, which was used to carry ammunition.

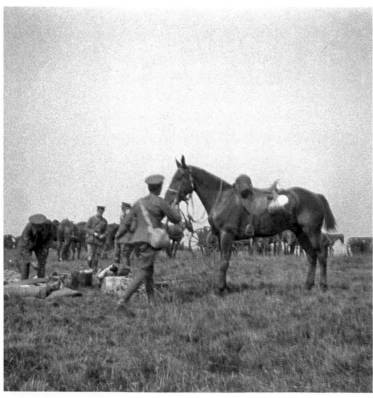

In the background of this picture can be seen horses harnessed to limbers and field guns.

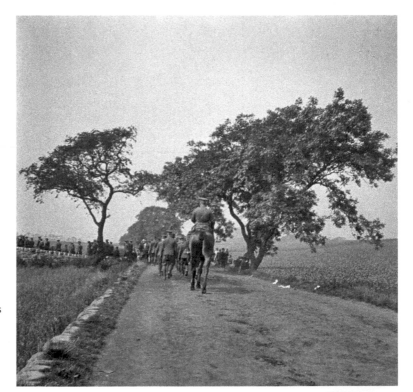

Looking west towards Berrylaw. This road, off William Street, is now just a path and is signposted 'Dean Plantation'.

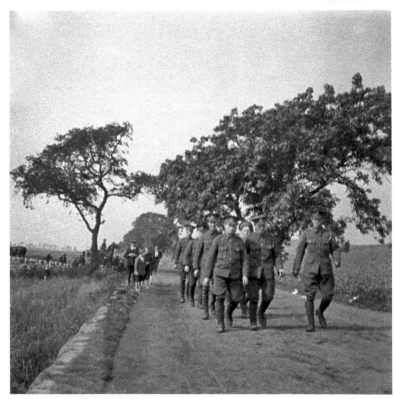

Looking westwards, the 9th King's (and a following of children) on Berrylaw Road.

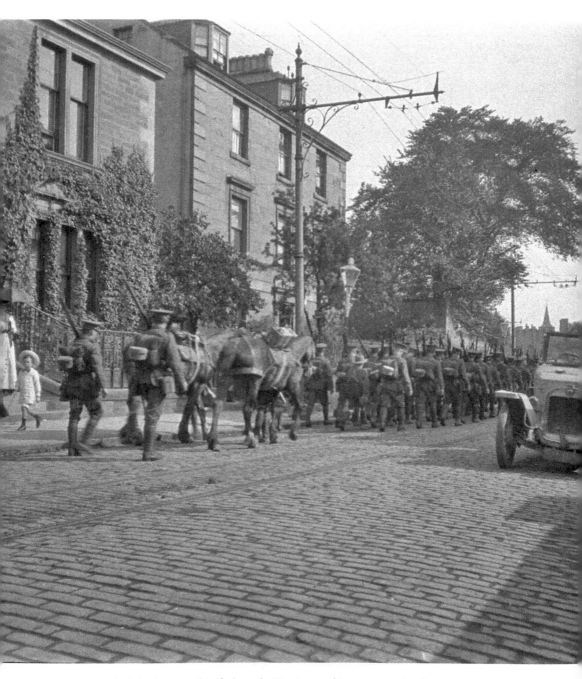

A wonderful photograph of the 9th King's marching eastwards along East Port. Note the distinctive Benachie, the old car and the tram lines. Trams were introduced to the town in November 1909. The nineteenth-century Benachie House was known as Hawthornbank until 1909. In 1933, it was bought by the Carnegie Dunfermline Trust for use as a music institute. The adjoining Carnegie Hall was built between 1933 and 1937.

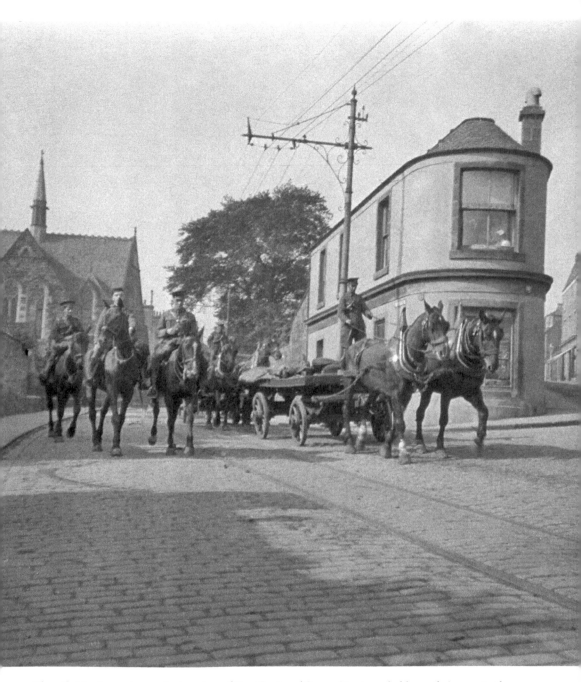

The 9th King's coming to the junction of East Port and James Street, probably on their way to the Public Park. The man on the left looks like a policeman. The rounded building on the corner of James Street and East Port was demolished in the 1920s as a result of road widening.

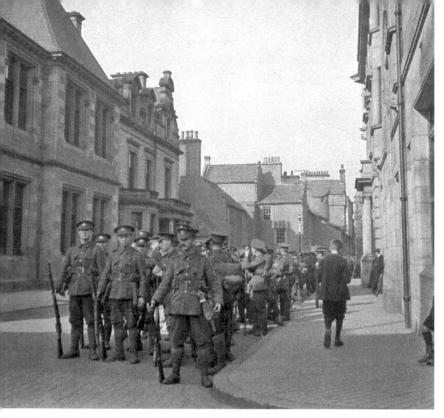

Standing at ease in Abbot Street, beside the Dunfermline Carnegie Library on the left. Opened in 1883, this was the first of Andrew Carnegie's libraries. The second was in Grangemouth.

This photograph shows the soldiers assembled in Abbot Street/Maygate, outside Auld Jimmy's shop.

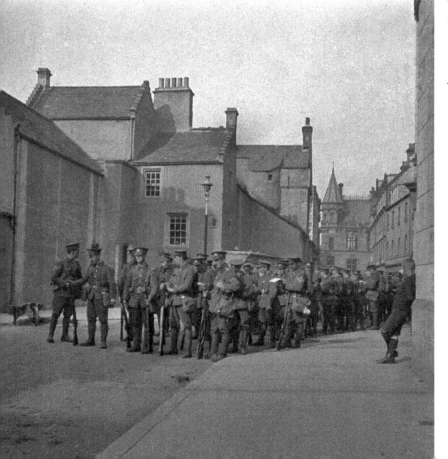